THE LITERATURE OF PHOTOGRAPHY

THE LITERATURE OF PHOTOGRAPHY

Advisory Editors:

PETER C. BUNNELL
PRINCETON UNIVERSITY

ROBERT A. SOBIESZEK
INTERNATIONAL MUSEUM OF PHOTOGRAPHY
AT GEORGE EASTMAN HOUSE

A HISTORY

OF

PHOTOGRAPHY

WRITTEN AS

A PRACTICAL GUIDE AND AN INTRODUCTION TO ITS LATEST DEVELOPMENTS

BY

W. JEROME HARRISON

ARNO PRESS

A NEW YORK TIMES COMPANY

NEW YORK ★ 1973

Reprint Edition 1973 by Arno Press Inc.

Reprinted from a copy in
 The University of Illinois Library

The Literature of Photography
ISBN for complete set: 0-405-04889-0
See last pages of this volume for titles.

Manufactured in the United States of America

————◆————

Library of Congress Cataloging in Publication Data

Harrison, William Jerome, 1845-1909.
 A history of photography.

 (The Literature of photography)
 Original ed. issued in Scovill's photographic series.
 1. Photography--History. I. Title. II. Series.
TR15.H32 1973 770'.9 72-9204
ISBN 0-405-04913-7

A HISTORY

OF

PHOTOGRAPHY

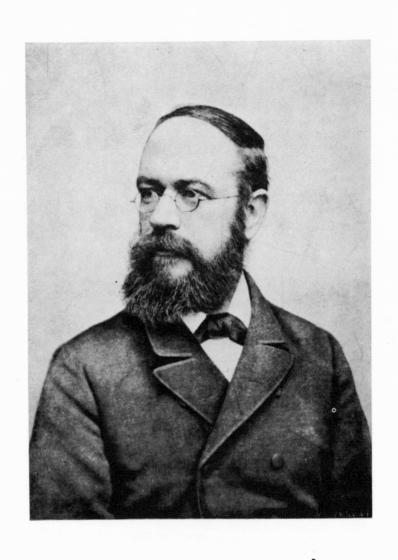

W. Jerome Harrison

A HISTORY

OF

PHOTOGRAPHY

WRITTEN AS

A PRACTICAL GUIDE AND AN INTRODUCTION TO ITS LATEST DEVELOPMENTS.

BY

W. JEROME HARRISON, F. G. S.,

WITH

A BIOGRAPHICAL SKETCH OF THE AUTHOR, AND AN APPENDIX BY
DR. MADDOX ON THE DISCOVERY OF THE GELA-
TINO-BROMIDE PROCESS.

NEW YORK:
SCOVILL MANUFACTURING COMPANY,
W. IRVING ADAMS, Agent.

1887.

THE PHOTOGRAPHIC TIMES PRINT.

CONTENTS.

PAGE

INTRODUCTION ... 5

CHAPTER I.
THE ORIGIN OF PHOTOGRAPHY................................... 7

CHAPTER II.
SOME PIONEERS OF PHOTOGRAPHY—WEDGWOOD AND NIEPCE 13

CHAPTER III.
THE DAGUERREOTYPE PROCESS................................... 21

CHAPTER IV.
FOX-TALBOT AND THE CALOTYPE PROCESS....... 28

CHAPTER V.
SCOTT-ARCHER AND THE COLLODION PROCESS...................... 38

CHAPTER VI.
COLLODION DRY-PLATES, WITH THE BATH 45

CHAPTER VII.
COLLODION EMULSION... 54

CHAPTER VIII.
GELATINE EMULSION WITH BROMIDE OF SILVER.................... 58

CHAPTER IX.
INTRODUCTION OF GELATINO-BROMIDE EMULSION AS AN ARTICLE OF
COMMERCE BY BURGESS AND BY KENNETT...... 64

CHAPTER X.
GELATINE DISPLACES COLLODION................................. 71

CHAPTER XI.
HISTORY OF PHOTOGRAPHIC PRINTING PROCESSES.................. 78

CHAPTER XII.
HISTORY OF PHOTOGRAPHIC PRINTING PROCESSES (Continued)...... 96

CHAPTER XIII.
HISTORY OF ROLLER-SLIDES ; AND OF NEGATIVE-MAKING ON PAPER
AND ON FILMS.. 107

CHAPTER XIV.
HISTORY OF PHOTOGRAPHY IN COLORS............. 117

CHAPTER XV.
HISTORY OF THE INTRODUCTION OF DEVELOPERS—SUMMING UP.. ... 126

APPENDIX.
DR. MADDOX ON THE DISCOVERY OF THE GELATINO-BROMIDE PRO-
CESS... 130

A BIOGRAPHIC SKETCH OF THE AUTHOR......................... 134

PREFACE.

As "Chapters in the History of Photography," a large part of this volume was originally published in THE PHOTOGRAPHIC TIMES. In that widely-read journal the "Chapters" attracted to themselves so much well-deserved attention, that, in response to the very evident demand on the part of the photographic fraternity, the publishers decided to present them in the more permanent and convenient form which their value and popularity seemed to require.

Assisted by the author, and with his approval, Mr. W. I. Lincoln Adams, editor of THE PHOTOGRAPHIC TIMES, has arranged the "Chapters" in their present form, added a biographical sketch of the author, and the supplementary chapters, by the author, on the History of Photographic Printing Processes and on the History of Photography in Colors; and the Appendix, by Dr. Maddox, on the Discovery of the Gelatino-Bromide Process.

The frontispiece portrait of the author is a "Moss-type," by the Moss Engraving Company, of this city, after a negative by Harold Baker, of Birmingham, England.

The Publishers.

NEW YORK, October 1, 1887.

INTRODUCTION.

ONE great charm of Photography is that it unites in the bonds of friendship men of all the countries under the sun— their common helper. Personally, I should feel grateful to Photography if it had done nothing more than make me acquainted with those kind friends beyond the seas who have taught me to realize so strongly the unity of our race, and to feel that between Englishman and American there ought to be the sincerest sympathy, the pleasantest rivalry.

I am especially glad that my first book on photography will be first published in the United States, for I am convinced that it will there find readers not less generous than critical, and not more critical than appreciative.

When our kind friend, Mr. W. J. Stillman—who has won distinction and is equally at home in the two hemispheres— first pressed me to write for the *Photographic Times*, he recommended "practical" subjects. And in this History of Photography I believe I have chosen something directly useful and practical, though, perhaps, a few will be at first disposed to question the utility of such a record of the past. "Don't tell us these old tales!" some budding camera knight of full twenty-four hours' standing will exclaim, "our processes are perfect, and we care for nothing else!"

But photography is an evolutionary science. The key to the proper comprehension of the present lies in the past; and no man can afford to neglect the rich mine of experience which is furnished by the work of his predecessors. Perhaps in no other art have so many things been discovered and rediscovered, and patented twenty times over, as in photography. Even to-day it only requires a diligent study of the photographic literature of the past to bring to light many germs which, with our more advanced knowledge, can be perfected and turned to sources of pleasure and of profit.

Then photography ought to be learned — and taught — historically. Let no man call himself a "photographer" on the strength of having fired off a few gelatine dry-plates. To

obtain a competent knowledge of the science, you must work your way experimentally along the historical path. Repeat the experiments of Niepce and Daguerre, of Fox-Talbot and Scott-Archer, and you will learn to appreciate the labors of these "fathers of photography"; will sympathize with their difficulties, and glory in their ultimate success.

Not only will you produce a collection of most interesting specimens, but you will accumulate a store of solid knowledge, and will return to your gelatine dry-plates a master instead of an apprentice.

To the many whose other avocations and want of time forbid so complete a course, we still say, "Study the past!" Buy the old books as well as the new ones; they will all teach you something. So far from photography having attained perfection, we believe it to be but as a little child. Great are our hopes and wondrous our visions of its future; but every advance must be made step by step, and to successfully climb the pyramid of knowledge—which, unlike other pyramids, is daily increasing in altitude—*we must start from the base!*

Then, have not the "men of might" who laid the foundations of our science, a claim that we should make ourselves acquainted with their lives and their work? What soldier is there that does not love to read of Wellington and Bonaparte, of Grant and Lee? With equal interest ought the "children of the sun" to follow the painful path of Niepce, and stand by the death-bed of Scott-Archer—the photographer who gave his precious discovery freely for the use of all, and who died poor and before his time, because he had overstrained his powers in the cause of our science.

Let us hope that the great increase in the number of photographic societies which has marked the last few years, will lead to the establishment of libraries in connection with them, and the formation of modest museums in which interesting relics, illustrating old processes, may be preserved, so that greater facilities may be afforded for the study of the history of photography. As an introduction to that history this humble book has been written by

W. Jerome Harrison.

Science Laboratory, Icknield Street, Birmingham, England.

A HISTORY OF PHOTOGRAPHY.

CHAPTER I.

THE ORIGIN OF PHOTOGRAPHY.

Early Records of the Action of Light upon Matter.—Photography is the child of optics and chemistry. As neither of these sciences attained anything like a full development until the present century, it is not surprising that the art of taking photographs was unknown to our ancestors. And yet there are many facts that must have been known, even to the ancients, whose meaning, if rightly appreciated, would have led to the early discovery of the art of photography. For example, lenses are all but absolutely necessary to the taking of photographs, and a lens has been found among the ruins of Nineveh, a city which was destroyed more than a thousand years before the birth of Christ. This lens is now in the British Museum. During the Middle Ages the manufacture and properties of simple lenses were well understood in Europe.

The changes produced by the action of light upon matter are so common as to be matters of every-day observation. At a very early stage of civilization the tanning or bronzing of the human skin by the solar rays must have been noticed, even if the black skin of the negro was not assigned to its true cause —a constant residence beneath the intense rays of a tropical sun. A hundred years before Christ, the Roman philosopher, Pliny, noticed and recorded the fact that yellow wax is bleached by exposure to sunlight. The Greeks knew well that certain gems—the opal and the amethyst more especially—lost their luster from the same cause; while the great Roman architect and painter, Vitruvius, was so conscious of the decolorizing effect of sunlight that he invariably placed his paintings in rooms facing the north.

The Alchemists and Horn Silver.—During the Middle Ages almost the only inquirers into the secrets of nature were the alchemists, who vainly sought the philosopher's stone which should transmute the baser metals into gold. But though their search was vain, yet, as so often happens, these experimenters—Roger Bacon, Albert Magnus, Paracelsus, and a host of smaller lights—although they did not find what they were looking for, yet they made many discoveries of great value. The storehouse of nature is so rich that even the blind seeker is rewarded. And so these old alchemists became acquainted with some of the most powerful agents of modern chemistry—the acids for example—and, as the centuries rolled by, their discoveries bore fruit.

Among those alchemists who experimented with the compounds of silver we find the name of Fabricius, who in 1556 published a book upon metals.

Horn-silver, or *luna cornea* as it was then termed, was the name given to a semi-transparent compound of silver and chlorine which occurred as an ore in the silver mines of Germany, but which Fabricius found could be prepared by adding a solution of common salt to a solution of silver nitrate. Fabricius and his co-workers appear to have been much surprised when they noticed that this silver compound—white when freshly prepared—quickly turned black when exposed to the sunlight; but as the fact appeared to have no relation to the object which engrossed all their thoughts—the search for gold—no attempt was made to inquire into the nature of this surprising change; a change which must also have been noticed by the miners who extracted the ore.

Schulze's Experiment.—During the seventeenth and eighteenth centuries many instances were recorded of the effect of light in changing the colors of bodies; but, as the result is most rapid and most striking in the case of compounds of silver, it was to these that attention appears to have been chiefly directed.

In 1727, J. H. Schulze actually obtained copies of writing by placing the written characters upon a level surface previously prepared with a mixture of chalk and silver-nitrate solution. The rays of sunlight passing through the translucent

paper blackened the silver compound beneath, except where it was protected by the ink forming the letters, and thus a white copy upon a black ground was obtained. Although we cannot, on the strength of this single experiment, assign to Schulze the title which Dr. Eder claims for him as the "discoverer of photography," yet it must be admitted that the experiment was a very remarkable one, and it is much to be regretted that it was not successfully and quickly followed up.

Scheele examines Silver Chloride.—Charles William Scheele of Stralsund (then a Swedish town), was a distinguished investigator, who may be considered as one of the founders of modern chemistry. In 1777, he made the first scientific investigation of the behavior of silver chloride under the influence of light. First he noted the action of differently colored light, showing that while the silver salt was quickly darkened by violet or blue light, the red and yellow rays had much less effect upon it. His results were confirmed by Senebier in 1782, who wrote that "in fifteen seconds the violet rays blackened silver chloride as much as the red rays did in twenty minutes." But Scheele also discovered the *cause* of the darkening. He exposed chloride of silver to the action of sunlight underneath water, reasoning, doubtless, that the water would arrest and dissolve any substance which might be given off under the action of light. When the white salt of silver had blackened, Scheele poured away the water and added to it a little silver nitrate. Immediately a white substance was formed (owing to the silver nitrate combining with chlorine dissolved in the water), which was silver chloride formed anew. Thus Scheele proved that the effect of white light upon silver chloride is to decompose it, and cause it to give up some or all of its chlorine. As to whether the black residue is metallic silver (which appears black when in a very fine state of subdivision), or is a compound known as silver sub-chloride (Ag_2Cl), that is a matter upon which chemists even yet are not agreed. Scheele's conclusions were doubted by Count Rumford, whose paper entitled "An Enquiry Concerning the Chemical Properties that have been attributed to Light," was published in the Philosophical Transactions of the Royal Society for 1798. He considered that the changes observed were due to *heat*

rather than to light; but his arguments were successfully con-
troverted by Robert Harrup, who, in the case of the salts of
mercury at all events, conclusively proved (*Nicholson's Jour-
nal*, 1802) that light alone was the determining agent of the
changes observed.

Invention of the Camera Obscura.—It was not till near the
close of the eighteenth century that any one, with the excep-
tion, perhaps, of Schulze, seems to have thought of applying
the changes of color produced by the action of light upon sil-
ver compounds to any practical purpose. And yet the instru-
ment called the camera obscura had long been known, and
those who gazed upon the beautiful pictures produced by its
agency must often have longed to find some method by which
they might be fixed and retained. Invented by the Italian
philosopher Baptista Porta about the middle of the sixteenth
century, the camera obscura at first consisted simply—as its
name implies—of a darkened room to which light was admit-
ted only through a single small hole in the window-shutter.
In such a room, when the sun is shining brightly, a faint in-
verted image of external objects, as the houses, trees, etc.,
upon which the window looks, is seen upon the white surface
of the wall or screen within the room which faces the window.
Porta improved this primitive contrivance by placing a double
convex glass lens in the aperture of the shutter, outside which
a mirror was placed to receive the rays of light and reflect
them through the lens. The image upon the screen within
was thus made brighter and more distinct, and was moreover
shown in a natural or erect position. Crowds flocked to
Porta's house in Naples to see these pictures painted by light,
glowing with color, and depicted with marvelous accuracy.
Soon further improvements were made, and the camera ob-
scura became a favorite adjunct to the country houses of the
wealthy, often taking the form of a small circular building,
erected if possible on a hilltop. The lens was then usually
placed in the center of the conical roof, with a slanting mir-
ror arranged so as to reflect the light from surrounding ob-
jects downward through the lens; the picture thus formed
was received upon the whitened surface of a table placed
within the little building. Such erections are still not un-

common in places of popular out-door resort, and interesting discoveries are not unfrequently made by those who have gained admittance, as to the doings of unsuspecting outsiders, who little think that their proceedings are pictured for the delectation of others.

Now the photographer's camera is a miniature camera obscura, being nothing more than a well-made box having a lens at one end and a ground glass screen at the other. Still, a modern camera made by one of the masters of the art of cabinet-making as applied to photography, and provided with a battery of first-class lenses, is nothing less than a work of art, and is correspondingly expensive.

Early Visions of Photography.—A Chinese tradition credits the sun with sometimes producing pictures of the neighboring objects upon the ice-covered surfaces of lakes and rivers. A similar idea must have possessed the mind of Fénélon, when, in 1690, he wrote his fable called "Une Voyage Supposé," descriptive of the imaginary journeys of an imaginary personage, in which the following passage occurs: "There was no painter in that country ; but if anybody wished to have the portrait of a friend, of a picture, a beautiful landscape, or of any other object, water was placed in great basins of gold or silver, and the object desired to be painted was placed in front of that water. After a while the water froze and became a glass mirror, on which an ineffaceable image remained."

But it was reserved for another Frenchman, Tiphaigne de la Roche, to make a still nearer guess as to the manner in which "nature printed" pictures would one day be produced. In 1760 he wrote a book entitled "Giphantie" (an anagram of his own name), containing a series of wild imaginings, one of which must have appeared especially improbable to his contemporaries, although it has since been literally fulfilled. The hero of "Giphantie" is carried by a hurricane to a strange land, where he is shown the method by which the native genii produced pictures. "You know," said the guide, "that rays of light reflected from different bodies form pictures, paint the image reflected on all polished surfaces, for example, on the retina of the eye, on water, and on glass.

The spirits have sought to fix these fleeting images; they have made a subtle matter by means of which a picture is formed in the twinkling of an eye. They coat a piece of canvas with this matter, and place it in front of the object to be taken. The first effect of this cloth is similar to that of a mirror, but by means of its viscous nature the prepared canvas, as is not the case with the mirror, retains a fac-simile of the image. The mirror represents images faithfully, but retains none; our canvas reflects them no less faithfully, but retains them all. This impression of the image is instantaneous. The canvas is then removed and deposited in a dark place. An hour later the impression is dry, and you have a picture the more precious in that no art can imitate its truthfulness."

After reading this very remarkable prophecy, one can hardly help thinking that De la Roche must have conceived the idea after viewing the pictures shown with Porta's "dark chamber," a contrivance which was then, as we know, in vogue.

CHAPTER II.

SOME PIONEERS OF PHOTOGRAPHY—WEDGWOOD AND NIEPCE.

Claims of Charles and of Boulton.—The discovery of photography, altogether or in part, has been claimed for at least two men, who attained distinction in science towards the end of the eighteenth century. It has been stated that Professor Charles, who was well known in Paris as a lecturer on chemistry and physics about the year 1780, not uncommonly (as a lecture experiment) obtained profiles of the heads of his students by placing them so that the required shadow of the features was cast by a strong beam of sunlight upon a sheet of paper coated with chloride of silver. As the light would discolor that portion of the paper upon which it fell, the result was a white outline of the face upon a black background. But this statement is a mere tradition, and the best authorities have considered it " too vague and improbable to be taken into serious account."

Some twenty years back, an attempt was made to prove that Matthew Boulton, the partner of James Watt, was acquainted with a method of producing photographs, at least as early as 1777. But the numerous pictures which about that date were sold by the famous Birmingham firm of Boulton & Watt, were executed by a mechanical process—possibly aquatint—the invention of an ingenious artist, Mr. Eginton, who was then employed at the great Soho factory. These pictures were of large size, as much as five feet by four, and were colored. In a series of pamphlets published in 1864–5, Boulton's grandson—Mr. M. P. W. Boulton—clearly proved that photography had nothing to do with the production of these pictures. Living in that district of Birmingham where Boulton and Watt did their work, we have carefully studied this question, and can endorse the conclusions arrived at and very ably stated by the younger Boulton. A claim to rank as a discoverer of photog-

raphy recently made on behalf of Lord Brougham rests only
on his statement that in a paper communicated by him to the
Royal Society in 1795, he suggested the use of a plate of ivory
rubbed with nitrate of silver, as a surface which might secure,
permanently, the pictures of the camera obscura. But as this
paragraph did not appear in the published paper (Brougham
says it was eliminated by the secretary), we cannot seriously
take it into account.

Copying by Sunlight— Wedgwood and Davy.—With the
dawn of the nineteenth century all things were propitious for
the rapid advancement of matters scientific. Great progress
had by this time been made both in chemistry and in optics;
while the art of experimenting—the knowledge of how to
question nature—had become familiar to many men of talent
and education. Thomas Wedgwood, fourth son of the great
potter, earnestly studied the action of light upon certain com-
pounds of silver. He was encouraged and assisted by Hum-
phrey Davy, then just rising into fame as a chemist, and after
Wedgwood's death Davy wrote an account of their work,
which appeared in the *Journal of the Royal Institution* for
1802. Wedgwood's best results were obtained by coating
paper or white leather with a weak solution of silver nitrate.
The more or less opaque object which it was desired to copy
was then placed on the prepared surface, and the whole ex-
posed to sunlight. In a few minutes, the unprotected portions
of the paper were darkened, and when the opaque object was
removed, its form remained in white upon a black ground.
Paintings on glass could be copied in this way, the light pass-
ing through the transparent and semi-transparent portions, and
blackening the sensitive paper placed underneath. Wedg-
wood noticed that "red rays, or the common sunbeams passed
through red glass, have very little action upon paper prepared
in this manner; yellow and green are more efficacious, but
blue and violet light produce the most decided and powerful
effects." These facts had been previously published by
Scheele and by Senebier, but Wedgwood does not appear to
have known of their work. The scantiness of scientific litera-
ture at that time, and the difficulty of communication between
different countries, were indeed great hindrances to progress.

The workers in any one country were usually ignorant of what had been done elsewhere ; so that the same track was pursued again and again, and the same discoveries made several times over. Davy made some important additions to Wedgwood's work. He found that the chloride was much more sensitive to light than the nitrate of silver. Both Wedgwood and Davy attempted to secure the pictures formed within a camera, upon paper coated with these salts of silver, but without success. Davy, however, using the more concentrated light of the solar microscope, readily obtained images of small objects upon paper prepared with silver chloride.

But there was another and more fatal objection to this method of " picturing by light," which not even Davy, with all his chemical knowledge, was able to surmount. When the copies obtained were exposed to daylight, the same agency which had produced the picture proceeded to destroy it. The action of sunlight upon the white or lightly shaded portions constituting the picture speedily blackened the entire surface of the paper or leather, causing the whole to become of one uniform tint in which nothing could be distinguished. To prevent this it was clearly necessary to remove the unacted-on silver salt after the image had been formed, and before the paper was exposed, as a whole, to daylight. Long-continued washing in water was tried, but proved ineffectual ; nor was a coating of transparent varnish found of any service. Davy does not seem to have pursued the process with much energy, and the whole thing dropped into obscurity. Still he clearly recognized its capabilities, for he writes : " Nothing but a method of preventing the unshaded parts of the delineations from being colored by exposure to the day is wanting to render this process as useful as it is elegant." In this copying process, devised by Wedgwood and improved by Davy, we see the germ of the ordinary method by which our negative photographs on glass are made to yield a positive proof or impression upon sensitized paper.

A Patient Photographer — Joseph Nicéphore Niepce.— The first man to obtain a permanent photograph was Joseph Nicéphore Niepce, who was born at Chalons-sur-Saone, March 7th, 1765. Well educated, his parents designed him for the

Church, but the outbreak of the French Revolution upset all their plans, and in 1794 Niepce fought in the ranks of the Republican army which invaded Italy. Ill-health soon compelled his retirement from active service, and, marrying, he settled down at Chalons; his brother Claude, to whom he was devotedly attached, residing with him.

Even during childhood, the fondness of the brothers Niepce for scientific pursuits had been very noticeable, and they now applied themselves to the task of invention, bringing out a machine called the pyrelophore, which propelled vessels by the aid of hot air; and a velocipede, the ancestor of our modern bicycle. Endeavoring to bring these inventions before the public, Claude went to Paris in 1811, and afterwards crossed over to England, where he settled down at Kew.

It was, apparently, about the year 1813 that Nicéphore Niepce began the experiments which resulted in his discovery of what may be called the bitumen process in photography. From his correspondence with his brother Claude, we learn something of this method; and when, in 1827, Nicéphore visited his brother at Kew, he brought with him many specimens of his work. These pictures, the first permanent photographs ever produced, Niepce desired to bring before the notice of the Royal Society, but as he declined to publish the process by which they were produced (being desirous to perfect it before making it public), the rules of the society compelled them to refuse Niepce's communication. Having examined several of the specimens presented by this early French experimenter to his English friends, we can testify to the successful manner in which he had succeeded in copying engravings.

Making but a short stay in England, Niepce returned to France, where, in 1829, he entered into a partnership with another investigator named Daguerre. But Niepce was not destined to complete his work, or even to publish his results; he died in 1833, at the age of sixty-eight. Although it is impossible to assign the title of "Inventor of Photography" to any one man, yet Niepce has probably the best claim to it. Quite recently a statue of Niepce has been erected at Chalons.

Lithography and Photography.—Lithography, invented by a German, Senefelder, in 1798, was successfully practiced in

France in 1812. Expert draughtsmen were required to execute the necessary drawings upon the prepared surfaces of the smooth blocks of limestone employed. Now Niepce thought that it might be possible, by the action of light, to cause designs, engravings, etc., to copy themselves upon the lithographic stone. The basis of all his work was the discovery that bitumen, or " Jew's pitch," as it was then commonly called, is rendered insoluble by the action of light. Niepce dissolved bitumen in oil of lavender, and spread a thin layer of it upon the stone. Next he varnished the drawing on paper, of which he desired to secure an impression—the varnish rendering the paper fairly transparent—and laid it upon the bitumenized stone. After exposing the whole to sunlight for an hour or so, the paper was removed and oil of lavender poured upon the bitumen, by which those portions of it that had been protected from light by the opaque lines of the' drawing were dissolved away, and the surface of the stone beneath was in those parts exposed. Thus the outlines of the original subject were reproduced with perfect truth. Lastly, by treating the stone with an acid, the exposed portions could be " bitten" or eroded more deeply, and it was then ready for printing from. Finding much difficulty in securing stone of a sufficiently fine and close grain, Niepce substituted metal, employing plates of polished tin, etc., on which to spread the bitumen. Although the results he obtained were far from perfect, yet they were very promising, and heliography, as Niepce named this method, has since proved very useful.

Niepce Secures Photographs in the Camera.—Having obtained pictures by what we may call contact-printing, Niepce's next endeavor was to apply his process to securing the beautiful views produced by the aid of a camera. For this purpose he tried the chlorides of silver and of iron, and gum guaiacum, whose sensibility to light had been investigated by Wollaston, in 1804. Nothing, however, answered so well in his hands as the surface of bitumen or asphalt, with which he had already been successful in heliography. When exposed to the action of the light forming the picture within a camera, the bitumen became insoluble in proportion to the intensity of the light by which the various parts of the image were produced, an effect

which we now know to be due to the oxidation, and conse-
quent hardening of this resinous substance. When the resin-
ized plate was removed from the camera, no picture at all was
visible on its surface. But by steeping the expósed plate in a
mixture of oil of lavender and petroleum, the still soluble por-
tions of the bitumen were removed. The shadows of the
landscape were then represented by bare portions of the metal
plate, while the insoluble resin which remained indicated the
brightest parts, or "high-lights" of the original. Obviously
such a picture would look more natural if the portions of
polished metal exposed could be darkened, and for this pur-
pose we know that Niepce employed various chemicals, and
among others iodine.

Correspondence of Niepce.—It is unfortunate that Nicé-
phore Niepce never published a single line descriptive of his
methods, so that it is only from his correspondence—and more
especially his letters to his brother Claude—that we can glean
our information. The difficulties of an experimenter in an
obscure French town, seventy years ago, were indeed great.
Niepce tells us that his first camera was fashioned out of a cigar
box, while his lenses were "the lenses of the solar microscope,
which, as you know, belonged to our grandfather, Barrault."
In a letter written to his brother in 1816, Niepce describes how
he secured what was probably the first picture ever taken in a
camera: "My object glass being broken, and being no longer
able to use my camera, I made an artificial eye with Isidore's
ring box, a little thing from sixteen to eighteen lines square.
* * * * I placed this little apparatus in my workroom,
facing the open window looking on to the pigeon house. I
made the experiment in the way you are acquainted with, and
I saw on the white paper the whole of the pigeon house seen
from the window. * * * * One could distinguish the
effects of the solar rays in the picture from the pigeon house
up to the window sash. The possibility of painting by this
means appears almost clear to me. * * * * I do not hide
from myself that there are great difficulties, especially as re-
gards fixing the colors, but with work and patience one can ac-
complish much."

"Work!" and "Patience!"—truly Niepce himself combined

these in no common degree. From the reference to white paper used in this early experiment, it would seem probable that silver chloride was employed. We know that Niepce used the substance, and that he gave it up, because, like Wedgwood and Davy, he was unable to fix or render permanent the pictures secured by its aid.

Niepce's Agreement with Daguerre.—This agreement bound the two investigators to communicate to each other all the processes which they had discovered for fixing the camera-image; and it went on to state that the two inventors were to share equally in any profits that might be obtained. In compliance with this resolution, Niepce drew up the following important statement, which is dated December 5th, 1829 : " The discovery which I have made, and to which I give the name of heliography, consists in producing spontaneously, by the action of light, with gradations of tints from black to white, the images received by the camera obscura. Light acts chemically upon bodies. It is absorbed ; it combines with them, and communicates to them new properties. Thus it augments the natural consistency of some of these bodies ; it solidifies them even ; and renders them more or less insoluble, according to the duration or intensity of its action. The substance which has succeeded best with me is asphaltum, dissolved in oil of lavender. A tablet of plated silver is to be highly polished, on which a thin coating of the varnish is to be applied with a light roll of soft skin. The plate when dry may be immediately submitted to the action of light in the focus of the camera. But even after having been thus exposed a length of time sufficient for receiving the impressions of external objects, nothing is apparent to show that these impressions exist. The forms of the future picture remain still invisible. The next operation then. is to disengage the shrouded imagery, and this is accomplished by a solvent, consisting of one part by volume of essential oil of lavender, and ten of oil of white petroleum. Into this liquid the exposed tablet is plunged, and the operator observing it by reflected light, begins to perceive the images of the objects to which it had been exposed, gradually unfolding their forms. The plate is then lifted out, allowed to drain, and well washed with water." To this Niepce adds: " It were, how-

ever, to be desired that, by blackening the metal plate, we could obtain all the gradations of tone from black to white. The substance which I now employ for this purpose is iodine, which possesses the property of evaporating at the ordinary temperature." We cannot but admire the graphic description of the phenomena of development here given by Niepce, and, without doubt, it formed the foundation of all the discoveries in photography that followed. It will be noticed that Niepce's method of development was a physical one only, for it consisted in simply washing away by a suitable solvent, the unacted-on and therefore still soluble parts of the bitumen.

Defects of Niepce's Process.—The chief objection to the beautiful and ingenious process discovered by Nicéphore Niepce was the great length of time for which the bitumenized plate needed to be exposed in the camera. For an ordinary landscape an exposure of from six to eight hours was required. During this time the shadows of objects changed from one side to the other, so that the resulting pictures were comparatively flat and spiritless, being devoid of the charming effects resulting from the contrast of light and shade. Another trouble arose from the fact that in the half-tones of the picture the bitumen was only hardened at the surface, the layer beneath remaining soft and soluble. When the developing liquid was applied this lower layer was apt to be dissolved, and in the final washing it sometimes carried away with it the hardened upper portion, so producing bare patches or defects.

Experiments in Heliography.—Most black varnishes are made from asphalt, and we can easily imitate Niepce's process by coating a glass or metal plate with a thin layer of such varnish and exposing it under a negative to bright sunshine. By subsequent washing with petroleum the picture is readily developed.

CHAPTER III.

THE DAGUERREOTYPE PROCESS.

Life of Daguerre.—Nicéphore Niepce was a man of a quiet and retiring disposition ; a student who was so immersed in his work and so desirous of perfecting it, that he hesitated—while as yet he felt it to be incomplete—to publish even the smallest details with regard to it.

But the man with whom Niepce entered into partnership— Louis Jacques Mandé Daguerre—was of a very opposite temperament, bold and energetic, desirous of fame and its accompanying rewards, accustomed to success and to the applause of the public.

Daguerre was born at Cormeilles, a village near Paris, in 1787. Neglected by his parents, his native talents asserted themselves, and while still young he became known as a scene-painter of great power and originality ; while the mechanical effects which he introduced to add to the realism of his stage-views were the admiration of all Paris.

In 1822, Daguerre opened a diorama in Paris, for which he executed paintings on a colossal scale for such scenery as the " Village of Goldau," the " Valley of Sarnen," etc. By painting on both sides of the canvas, and showing the picture first by reflected, and then by transmitted light, very remarkable changes and effects could be produced.

In the sketches from nature which Daguerre made as a preliminary aid to the execution of these immense pictures, he frequently employed the camera obscura ; and it was the remarkable beauty and perfection of the images produced by this instrument that determined the artist to attempt the discovery of some means by which they could be permanently retained.

Without any scientific education or training this task would have seemed to most persons a hopeless one ; but perhaps

Daguerre's very ignorance of the difficulties to be encountered was one cause of his perseverance. The date of his first attempts appears to have been about 1824, and during the next two or three years we hear of his paying frequent visits to the shop of Chevalier, a well-known optician, of whom Daguerre purchased the camera, lenses, and other articles necessary to his new pursuit.

In 1826, Daguerre was informed—probably by Chevalier—that a gentleman at Chalons had already made considerable progress toward the end which he was himself desiring to attain. Letters addressed to Niepce received, however, but curt responses, and it was not till 1827, when Niepce passed through Paris on his way to England, that he entered into cordial relations with Daguerre. The partnership between these two workers, which was established in 1829, was continued after the death of the elder Niepce, Isidore Niepce taking the place of his father.

Publication of the Daguerreotype Process in 1839.—Year after year passed away and left our scene-painter still toiling after his ideal—ever endeavoring to fix the fleeting images formed by the lens of his camera. His ordinary work is neglected, but he passes nine-tenths of his time in his laboratory. It was at this period that Madame Daguerre sought advice as to the sanity of her husband, and was not, perhaps, much comforted by the assurance of the men of science whom she consulted that the object of her husband's researches was "not absolutely impossible!" Five years after the death of Niepce his partner was able to announce that he had overcome all difficulties, and that henceforth nature would depict her own likeness with a pencil of light. In 1838, Daguerre attempted to form a company which should acquire and work the new process; but the Parisian public were utterly incredulous, and the shares were not taken up. In this extremity Daguerre showed his specimens, and, in confidence, explained his method to the eminent French astronomer and physicist, Arago. Arago's admiration and delight with this new and wonderful process by which objects were made to draw their own pictures were unbounded. As a man of science, and of world-wide reputation, his endorsement of the value of Daguerre's dis-

covery at once established its worth, and on his recommendation the French Government awarded to Daguerre a life pension of 6,000 francs, and to Isidore Niepce one of 4,000 francs per annum, on the condition that the invention should be published without patenting it; this money being paid by France for "the glory of endowing the world of science and of art with one of the most surprising discoveries that honor their native land." Notwithstanding this official statement, a patent was taken out by Daguerre in one country—England—in 1839.

Daguerre is said to have placed a written account of his process in the hands of Arago in January, 1839, and at the same time to have publicly exhibited specimens of the results which he had up to that time obtained; but no details were revealed, nor was the paper published until the meeting of the Academy in August of that year. The new process was named *Daguerreotype*, and the excitable inhabitants of the French metropolis went into ecstacies over it. Nevertheless, the daguerreotype process was, at the time of its publication, very imperfect, and it was destined to undergo important modifications and improvements during the next three or four years.

The news of Daguerre's wonderful discovery soon spread to other countries, and the inventor obtained a rich reward by the sale of apparatus, and by the instruction of hundreds who flocked to Paris to learn the details of the new art. A keen observer—Sir John Robinson—wrote as follows, in 1839, to a friend in the United States: "Circumstances led to my being included in a small party of English gentlemen who were lately invited to visit the studio of M. Daguerre to see the results of his discovery. I satisfied myself that the pictures produced by his process have no resemblance of anything, as far as I know, that has yet been produced in this country. Excepting the absence of color, they are perfect images as seen by reflection from a highly polished surface. The subjects which I saw were views of streets, boulevards and buildings; vacillating objects made indistinct pictures. There can be no doubt that when the daguerreotype process is known to the public it will be immediately applied to numberless useful processes; and even the fine arts will gain, for the eye, accustomed to

the accuracy of the Daguerre pictures, will no longer be satis-
fied with bad drawing, however splendidly it may be colored."
Every word of this prediction has since been fulfilled.

Daguerre died in 1851, aged sixty-three. In 1883, a bust
of this ardent worker was unveiled at Cormeilles, funds for
its execution having been contributed by photographers of all
civilized nations. Viewing his whole career, Daguerre must
be considered as a fortunate man. Not only did he reap much
honor and material benefit from his discovery, but he lived to
see photography rise to an important place amongst the arts
and sciences.

How Daguerre was Led to his Discoveries.—The materials
employed by Daguerre in his early experiments—between
1824 and 1829—appear to have been the same as those used
by Wedgwood and Davy—the chloride and nitrate of silver
spread upon paper; and he did not advance upon, if, indeed,
he equaled, the results obtained by the two English chemists.
After entering into partnership with Niepce, and learning the
details of his bitumen process, Daguerre followed for a time
in the same track; but further study enabled him to work out
improvements and modifications which led him ultimately to
a greater success. We know that Niepce sometimes used
metal plates coated with silver; moreover, he employed iodine
to darken these plates after the picture had been developed.
Using these two materials—plates of silver and vapor of iodine
—Daguerre found that the iodide of silver, formed by expos-
ing silver to the vapor of iodine, was sensitive to light. When
such "iodized silver plates" were exposed within the camera,
faint images of bright objects were impressed upon them in
the course of two or three hours.

Development by Mercury Vapor.—At this stage a happy
"accident" occurred, which revealed to Daguerre a method by
which not only was the time of exposure necessary to secure a
good picture greatly reduced, but the distinctness and beauty
of the image was much enhanced. It appears that one day
Daguerre removed from his camera a plate, which, either from
the shortness of the exposure or the dullness of the light, showed
no sign of an image. He placed this blank plate in a store
cupboard, intending to clean the surface and use it again. But

what must have been our photographer's surprise when, on taking out this plate the next morning, he found upon its surface a distinct and perfect picture! Another prepared plate was quickly exposed for an equally short time within the camera, and again a sojourn of twenty-four hours within the magic cupboard sufficed to bring out a picture. The next step was to ascertain to which of the numerous chemicals kept within the cupboard this marvelous effect was due. By a process of elimination it was at last traced to a dish full of mercury.

Delighted by this fortunate discovery, Daguerre at once proceeded to place his exposed plates over a dish of warm mercury, when the vapor proceeding from the liquid metal was found to settle upon the iodized silver in exact proportion to the intensity of the light by which each part of the plate had been affected. This was, in fact, a process of "development," an invisible or "latent" image being strengthened and thereby made visible. Some such method of "developing" the originally feeble impressions produced upon sensitive plates by a short exposure to light has been found necessary in every photographic process.

How Daguerreotypes were Fixed.—Another advance made by the French artist was the discovery of a fixing agent. This was neither more nor less than a strong solution of common salt, in which the plates were soaked after development, and which dissolved and washed away the iodide of silver that had not been acted on by light. But when, almost immediately after the publication of the daguerreotype process in 1839, Sir John Herschel drew attention to the superior qualities of hyposulphite of soda as a solvent of the silver salt, Daguerre immediately adopted it for clearing and fixing his exposed plates. We may mention that this substance, so valuable to every photographer, was discovered by Chaussier in 1799, and its power of dissolving the haloid salts of silver had been described by Herschel as early as 1819.*

Improvements in the Daguerreotype Process.—The first

* See paper on "Hyposulphurous Acid and Its Compounds," *Edinburgh Philosophical Journal*, vol. i., pp. 8, 396.

Daguerreotypes were so delicate that the merest touch of the finger was sufficient to mar their beauty, and, when exposed to the air, they rapidly tarnished and deteriorated. This defect was remedied by M. Fizeau, who gilded the image by means of a mixture of chloride of gold and hyposulphite of soda. This solution was poured over the silver plate, which was then heated until the liquid evaporated, leaving a thin coating of gold upon the picture, which was thereby rendered more distinct, as well as more permanent.

Another great improvement was introduced by Mr. Goddard, a London science lecturer, in 1840. He exposed the iodized silver plate to the action of bromine vapors, thereby forming a bromide of silver upon the plate in addition to iodide of silver. In 1841, M. Claudet used chlorine vapors in a like manner. Plates prepared by either of these methods were found to be far more sensitive to light than those which had been simply iodized. In fact, the time required to produce a picture in the camera was thereby reduced to from one to five minutes, or, with a very good light, to less than one minute.

As the three elements referred to above were only discovered, chlorine in 1774, iodine in 1811, and bromine in 1826, we see that photography was hardly possible before the present century.

Introduction of Portraiture by Photography.—After the improvements of Goddard and Claudet, which were quickly adopted by Daguerre, the production of portraits by the daguerreotype process became comparatively easy. In the very first attempts at portraiture, which appear to have been made in America by Draper and Morse, in 1839, the sitter's face was covered with white powder, the eyes were closed, and the exposure, lasting for perhaps half an hour, was made in bright sunshine! To lessen the glare of light, which painfully affected the sitter, Draper caused the sunlight to pass through a large glass tank containing a clear blue liquid—ammonia sulphate of copper—before falling upon the sitter, thus filtering out most of the heat rays, which could well be spared, as they possess little or no actinic value. In 1840, Beard and Claudet opened photographic studios in London; Davidson followed

suit in Edinburgh, and Shaw in Birmingham, and soon daguerreotypy became a trade. For landscapes, etc., the daguerreotype process was but seldom employed, though we read of a fine instantaneous picture of New York Harbor being secured by its aid.*

Defects of the Daguerreotype Process.—The expense of the plates, which were usually of copper plated with silver, was a serious objection to the daguerreotype process. As late as 1854 we find the price of daguerreotypes in England was two and a half guineas each for the quarter-plate size ($4\frac{1}{4}$ x $3\frac{1}{4}$), and four guineas each for half-plate size. The cleansing and polishing of the silver surface on which the picture was to be produced, was a most troublesome task, necessitating great care and a vast amount of labor in the production of the "black polish" which was necessary. It must also be remembered that there was practically no power of multiplying a daguerreotype—a fact due to the opacity of the silver plate. It is true that Grove (now Sir W. R. Grove, one of Her Majesty's Justices) devised a method of etching daguerreotypes with acid, so that they could be used in a printing press; but, practically, this method was a failure.

The daguerreotype held sway for about ten years only, from 1839 to 1851. It was more popular in America† than in England; indeed, in the latter country, specimens of the art are now quite rare. With all its faults it was an immense advance on anything previously known, and entitles Daguerre to rank with the leading inventors of the nineteenth century.

* The original is in the possession of Mr. J. Werge, of Berners Street, London, to whom I am indebted for a copy.

† For an admirable description of the faults and merits of a daguerreotype portrait, see Hawthorne's "House of the Seven Gables," chap. vi.

CHAPTER IV.

FOX-TALBOT AND THE CALOTYPE PROCESS.

Life of Fox-Talbot.—While Daguerre was pursuing his researches into matters photographic, in France, another worker was advancing toward the same goal in England, though by a different road.

Henry Fox-Talbot, born February, 1800, was of high lineage; the Talbots taking rank among the oldest families in England; while his mother—Lady Elizabeth Fox-Strangways —was the eldest daughter of the Earl of Ilchester.

The future discoverer of photography graduated at Cambridge with high honors, in 1821. He sat for two years in Parliament, but politics had no charms for him, and in 1834 he retired from public life to devote himself wholly to scientific research.

Talbot was a very versatile student of nature. His earliest work was mathematical; but between 1826 and 1834 he published five papers upon various phenomena connected with light. Then for many years photography engrossed his thoughts; but in after life he studied and wrote on "Spectrum Analysis," the "Cuneiform Inscriptions of Egypt," etc. Altogether fifty papers from his pen appeared in various scientific periodicals between 1822 and 1872.

Fox-Talbot died at his family seat, Lacock Abbey, in Wiltshire, on the 17th of September, 1877, full of years and honor. As a discoverer of photographic processes, he may fairly claim to be placed on an equality with Niepce and Daguerre.

Talbot's Early Work in Photography.—Talbot tells us that it was in 1833, while sketching the beautiful scenery of the Italian lakes with the aid of a camera obscura, that he was struck with the idea that it might be possible to fix, and retain permanently, the exquisite fac-similes of surrounding objects produced by the aid of that instrument.

Six years of steady work at the problem followed, at the end of which the publication of Talbot's process—for he succeeded in devising a means by which his object was attained—was hastened by the news that a Frenchman had also achieved success in fixing the camera-image.

It was on the 25th of January, 1839, that Professor Faraday described the new method of "Photogenic Drawing" (for so Talbot styled his invention) to the members of the Royal Institution—then, as now, a very popular London scientific club—and invited them to inspect a collection of drawings produced solely by the aid of light. On the 31st of the same month, a paper giving a full description of the method was read by Talbot before the Royal Society; this paper was shortly afterwards published in the *Philosophical Magazine*. Thus the publication of Talbot's process was made before that of Daguerre.

But when the two methods came to be compared it was found that they were essentially different. Talbot had followed up in his photographs on paper, the line of research indicated by Wedgwood; while Daguerre's method with polished silver plates was built upon the foundation furnished by Niepce; thus each had completed the work of his own countryman.

The Method of Photogenic Drawing.—Talbot's success was due, in the first place, to the fact that he had succeeded in rendering chloride of silver far more sensitive to light than Wedgwood or Davy had been able to do. Taking fine writing-paper, he soaked it in a weak solution of common salt, and then brushed one side of the paper twice over with a solution of nitrate of silver. When this was done, what chemists call "double decomposition" took place, and chloride of silver was formed in the pores and upon the surface of the paper; while mingled with the chloride there was also a slight excess of the nitrate of silver. It was to this use in combination of the two salts of silver—the nitrate being in excess—that the increased sensitiveness to light which paper so prepared was found to possess was due. Talbot found that paper treated in this way was darkened by even a momentary exposure to bright sunlight. By its aid he readily secured images of objects in the

solar microscope. But his crowning triumph was attained when, after an exposure of about an hour, he succeeded in obtaining an impression of the picture formed by the lens within the camera obscura. Talbot states that he had reached this point in 1835, and that in that year he secured several camera pictures of his residence, Lacock Abbey.

How Talbot Fixed his Pictures.—It will be remembered that it was the want of a fixing agent which baffled Sir Humphy Davy in 1802. But Talbot was more fortunate. After well washing his photographs he soaked them either in a solution of common salt, or in a solution of potassium iodide or bromide. By this treatment he found that his pictures were rendered permanent; at least they could be freely examined in the daylight without further darkening.

The Calotype or Talbotype Process.—Fox-Talbot did not rest content with his early successes. After the publication of Daguerre's paper, in 1839, he tried the iodide of silver instead of the chloride; and above all he succeeded in discovering a method of development by which the time of exposure necessary to secure a picture was very greatly reduced. In Talbot's early experiments the sensitive paper had to remain at the back of the camera until the image was printed-out upon it by the action of light; and for this a good light and a long period of time were necessary. But in September, 1840, Talbot states he discovered that if the sensitive paper be brushed over with a mixture of gallic acid and nitrate of silver, and be then exposed, while still wet, within the camera, the time necessary to secure a picture is only two or three minutes. He also found that the paper might be dried and exposed in that state, the image being subsequently brought out or "developed" by brushing over it more of the "gallo-nitrate of silver" solution.

Reade Independently Discovers Development by Gallic Acid.—It is tolerably certain that in the system of development described in the last paragraph, Talbot had been anticipated by a few months by the Rev. J. B. Reade, a well-known English clergyman. We have seen that Wedgwood had noticed, some forty or fifty years before the time of which we are now speaking, that copies by light were produced most rapidly when leather was used as a support for the salts of silver.

Reade also found this to be the case, and as his inroads upon his wife's stock of white kid gloves were not unnaturally objected to by that lady, he was led to the discovery that the increased sensitiveness to light was due to the solution of nut-galls with which leather is impregnated during the operation of tanning. Finally, he secured in what may be termed the essence of the galls—gallic acid—a substance capable of strengthening or developing the invisible photographic, or, as it was then termed, the *latent* image, which is formed, after even a very short exposure, upon the surface of the sensitive paper within the camera.

Talbot Patents the Calotype Process.—Talbot patented his calotype (beautiful picture) process in February, 1841. It is the third British patent for photography, the two previous ones being for the daguerreotype process. The calotype process was also frequently called Talbotype, in honor of the discoverer. The patent was afterwards disputed in the law courts on the ground of its "previous discovery" by the Rev. J. B. Reade; but it was upheld by the judge mainly for the reason that Reade did not properly publish or make known his discovery.

Outline of the Calotype Process.—The paper was carefully selected, of a close, even texture and fine surface. A solution of nitrate of silver (100 grains to six ounces of water) was brushed over one side of the paper and allowed to dry. It was then dipped into a solution of potassium iodide (500 grains to one pint of water), where it was left for two or three minutes. During this time the iodine combined with the silver to form iodide of silver. Lastly, the paper was rinsed in pure water and dried, when it was seen to be covered with a pale yellow coating of iodide of silver, which in that condition was practically unacted upon by light.

When it was desired to use this calotype paper, it was taken into the dark-room and brushed over with "gallo-nitrate of silver," made by mixing a solution of nitrate of silver (50 grains to the ounce) with one-sixth its volume of strong acetic acid, and adding an equal quantity of a saturated solution of gallic acid. The paper so prepared might be used wet, or it might be dried and kept for use at some future time. In

either case the picture could be subsequently brought out by brushing more gallo-nitrate of silver over the exposed surface ; though, if the paper was exposed while still wet, this was not absolutely necessary. Finally, the picture was fixed by well washing first in water, then in a solution of potassium bromide or some other soluble bromide, and then in water again.

In a patent taken out in 1843, Talbot claimed the use of a hot solution of " hyposulphite of soda (or any other soluble hyposulphite)," to give increased whiteness to calotype and other photographic pictures, and at the same time make them more permanent ; but this claim was quite indefensible, since Sir John Herschel had announced the power of this substance to dissolve the salts of silver as early as 1819, and had again called attention to its value for this purpose in 1840.

Photographic Negatives and Positives.—Niepce found that in the pictures obtained on his resinized plates, the lights and shades were just the reverse of those of nature; the whitest parts of the original objects being represented by the dark surface of the insoluble parts of the bitumen, while the shadows were indicated by the bared surface of the metal plate. In the same way Talbot found that the brightest parts of any landscape were represented by black patches of reduced silver upon his sensitive paper, while those parts of the paper upon which little light fell (the dark shadows, etc., of the landscape) remained white. Thus the developed image upon a sheet of calotype paper was the exact reverse, as far as light and shade were concerned, of the objects depicted. To such a picture Sir John Herschel, in 1841, applied the name of "negative." But paper is a semi-transparent substance, and by oiling or waxing it its transparency can be greatly increased. This fact, combined with the reversed nature of the original, enabled Talbot to obtain true copies of any negative by placing a piece of sensitive paper underneath the negative, and then exposing it to sunlight. The rays of light passing through the clear or transparent parts of the negative, blackened the paper beneath. After a sufficient time had elapsed the lower sheet of paper was removed, and it was then found to present a correct picture in black and white of the original objects.

To such a copy Herschel applied the name of "positive." It is obvious that in this way any number of positives could be obtained from a single negative, and in this respect the calotype process had a great advantage over the daguerreotype.

Publication of the "Pencil of Nature."—In 1843, Fox-Talbot visited Paris, lecturing on his calotype process to large audiences, and instructing the Parisian photographers in his method. To make generally known its capabilities, he began, in 1844, the issue of "The Pencil of Nature," a book which appeared in six parts, containing twenty-four calotype plates, between 1844 and 1846; it is a handsome quarto, and was sold for three guineas. This book is now very scarce, but in all the various copies which I have examined the pictures are more or less faded, the fading extending gradually from the edges to the center. The fact is that the necessity for a very thorough washing of each print to free it from hyposulphite of soda was not fully recognized in those early days of the art.

Later Work of Fox-Talbot. — After the introduction of Archer's collodion process, in 1851, Talbot devised a modification of it by which he obtained instantaneous pictures, as those are called which receive an exposure of a fraction of a second only. Perhaps the experiment which he performed in the lecture room of the Royal Institution in proof of his success has never been surpassed. Fastening a page of the *Times* newspaper to the edge of a revolving wheel, a clear photograph of every letter was obtained by the aid of the electric discharge of a battery of Leyden jars. Now it is known that the brilliant spark of light produced by such a discharge does not continue for more than the ten-thousandth part of a second. This "instantaneous process" was, however, complicated and difficult, and only its inventor was successful with it.

In 1852, Talbot invented a process of engraving on steel plates by the action of light upon a surface composed of gelatine and bichromate of potash, to which he gave the name of photo-glyphy. About 1854 he introduced albumen to give a gloss to the surface of the paper on which photographs are printed.

Defects of the Calotype Process.—It is hardly possible to

overrate the difficulties which photographers had to contend with half a century ago. Many of these difficulties were extraneous to their art. Thus hyposulphite of soda was, in 1840, a chemical curiosity, and for years afterward its price was six shillings per pound; *pure* chemicals, too, were hardly to be obtained, so that the worker was often forced to manufacture his own materials.

The calotypists were especially at the mercy of the papermakers. Canson, in France, and Turner, Hollingworth, and others, in England, made good paper, but still the grain was perceptible, and it was frequently uneven, knotty, and speckled with particles of metal from the machinery of the paper mills. Then it was difficult to get the paper to lie flat in the darkslide, and its comparative opacity made the negatives print slowly. To remedy the latter defects, the French experimenters, Le Gray and Blanquart-Evrard, introduced, about 1850, the method of waxing the paper by dipping it in melted wax and then ironing it between sheets of blotting-paper. This made the paper more even in texture and very translucent. It was then sensitized, exposed, and developed in the usual way.

Light for the Dark-Room.—From the moment that the silvered plate of Daguerre, or the sheet of paper used by Talbot, was fully sensitized, it became impossible to expose it to ordinary light. The only white light allowed to fall upon the sensitive surface must be that which passes through the lens of the camera, and by that light the image is imprinted on the film containing the silver salt. But it is impossible, or at all events-most inconvenient, to go through the operations of sensitizing and developing the plates in utter darkness. Here the fact discovered by Scheele, in 1777, comes to our aid. He found that red light produced no chemical effect upon the chloride of silver; and, speaking of the ordinary salts of silver employed in photography—the chloride, the iodide, and the bromide—it may be said that they are unaffected by pure red light. Even yellow light has little or no effect upon these substances if they are contained in collodion; but when bromide of silver in gelatine is tested in the same way, a few minutes' exposure to strong yellow light will be found to produce a change. Capt. Abney, however, has recently prepared

bromide of silver in such a molecular condition that it is strongly affected even by the red rays. Speaking generally, however, we may say that no harm is done to the sensitive surfaces ordinarily used by the photographer by a few minutes' exposure to red, or even orange light, and this space of time is sufficient to enable him to perform the various operations which are necessary. I have elsewhere recommended the use of covers of red card-board for all the flat dishes in which sensitive plates or paper are manipulated; and by using trays fitted with lids of ruby glass, it is quite possible to develop plates in any ordinarily lighted room. Thus the photographer's "dark-room" would be more properly called the "red-room," for its windows are usually glazed with ruby glass, and its gasjets and lamps fitted with ruby globes.

In 1844, Claudet actually took out a patent for the use of red light in photographers' dark-rooms; but he does not appear to have attempted to enforce it. During the collodion epoch (1851–80), yellow light was generally employed to develop by. For our gelatine dry-plates, either an orange or a ruby-colored light is preferable.

Contrast between Daguerreotype and Talbotype.—For ten or twelve years after the publication of the discoveries of Daguerre and Talbot, their processes—so distinct in method, although aiming at a like result—held joint sway over the little world of photography. By professional portraitists the Daguerreotype process was preferred, owing no doubt to the clear sharp pictures and beautiful detail which could be secured thereby; in part, also, their preference may have been due to the high prices which were cheerfully paid for pictures on "plates of silver." Amateurs, on the other hand, usually employed the Talbotype process; it was less expensive, less cumbrous, and permitted of the multiplication of the results obtained—for one good negative would furnish a large number of positive copies.

Herschel Introduces Glass Plates.—Photography is indebted to Sir John Herschel for many great improvements. The "famous son of a famous father," he was born in 1792, and was therefore in the zenith of his powers at the time of Daguerre's discovery (1839). He immediately suggested the

use of glass plates as a support for the sensitive salts of silver; recognizing in the transparency, rigidity, and cheapness of glass, together with its indifference to the chemicals employed, properties of the highest value in photography.

Herschel's plan was to place his glass plates at the bottom of a vessel containing finely divided silver chloride in water. The white silver salt was slowly deposited, in a uniform film, upon the upper surface of the glass. The water was then syphoned off, and the plate dried and exposed to the camera. The images obtained in this way were, however, very faint, and although some success attended Herschel's attempts to intensify them by electro-deposition, still good prints could not be obtained. At that time it was not known that silver chloride is unaffected by light, unless there be some substance mixed with it which is capable of attracting and combining with the chlorine which is liberated, under such conditions, by the action of light.

The Albumen Process on Glass.—Niepce de St. Victor, born 1805, died 1870, nephew of *the* Niepce, improved on Herschel's plan by recognizing the fact that it is necessary to coat the glass plates employed in photography with a film of some suitable substance, in and on which the particles to be affected by light may rest. For this purpose he employed albumen, beating up white of egg with potassium iodide (20 grains per egg), potassium bromide (four grains), and common salt (two grains). The clear liquid so obtained was poured upon the glass plate, dried, and heated until the albumen hardened and became insoluble. It was then dipped into a bath of silver nitrate, where a chemical change took place, resulting in the formation of iodide and bromide of silver within the pores of the albumen. The plate thus sensitized could either be exposed while wet, in the camera, or it might be rinsed, dried, and kept in a dark place till wanted. Development was effected by brushing a solution of gallic acid over the albumenized plate. This process was published in 1848, and improvements in it were quickly effected by two other French investigators—Blanquart-Evrard and Le Gray.

This albumen process was a considerable advance. The transparency of the glass permitted the production of positive prints at a rapid rate; while the clear and delicate film of albu-

men furnished a capital medium for holding the molecules of the sensitive silver salts, and securing their adhesion to, and equal distribution over, the surface of the plate. It is a mistake, however, to suppose that such substances as albumen, collodion, and gelatine, are nothing more than vehicles in which the sensitive molecules are contained. They each exercise an influence—differing in degree—upon the silver salt imbedded in them, by which the decomposing action of light is facilitated. In Great Britain the albumen process was practiced successfully about 1850, by Messrs. Ross and Thomson, of Edinburgh, whose pictures of architectural subjects on plates fifteen inches square were greatly admired. Many travelers also used dry-plates prepared on this system. Its chief drawback was the length of exposure necessary—from five to twenty minutes under ordinary conditions.

CHAPTER V.

Discovery of Gun-Cotton.—Schönbein, the famous Swiss chemist, discovered, in 1846, that when ordinary cotton is soaked in a mixture of nitric and sulphuric acids its properties become greatly changed. The explosive substance so obtained received the name of gun-cotton, or insoluble pyroxyline. When the acids were slightly dilute, or when the time of soaking was very short, a less dangerous compound was obtained, which was known as soluble pyroxyline.

Preparation of Collodion.—In the next year—1847—an American investigator named Maynard (of Boston), showed that when soluble pyroxyline was dissolved in a mixture of ether and alcohol, a somewhat viscid liquid was produced, to which he gave the name of collodion. When this collodion was poured out upon a level surface, as that of a sheet of glass, the ether quickly evaporated and a delicate skin or film was left behind. When dry this film was fairly tough and horny. Collodion formed so admirable a covering for bruises, etc., preventing the access of air, that it speedily became of use in surgery.

Collodion Introduced into Photography.—In 1849, a Frenchman, Gustave Le Gray, suggested that collodion might prove useful in photography. In his book—which was translated into English in 1850—he writes, "I have just discovered a process upon glass by hydrofluoric ether, the fluoride of potassium and soda dissolved in alcohol 40 degs. Fahr., mixed with sulphuric ether, and afterwards saturated with collodion; I afterwards react with nitrate of silver, and thus obtain proofs in the camera in five seconds in the shade. I develop the image with a very weak solution of sulphate of iron, and fix with hyposulphite of soda."

Another early investigator in this line was Robert J. Bing-

ham, who, as assistant to the great Faraday, made the acquaint-
ance of collodion immediately on its introduction into England
in 1847. In a book published in 1850, he gives, first Herschel's
method; then a method with albumen, then one for coating
glass plates with isinglass, and finally adds, " we may, in place
of the gelatine (isinglass) employ a number of other substances
to form an adherent film upon the glass. The following are a
few of those we have experimented with and found to answer
moderately well—gluten, collodion, varnishes, etc." But al-
though Le Gray and Bingham may take the credit for having
been the first to *suggest* a possible use of collodion in photog-
raphy, yet the merit of the invention and publication of the
collodion process proper belongs entirely to Frederick Scott-
Archer; his article describing this method first appearing in a
London periodical called *The Chemist*, in March, 1851.

Life of Scott-Archer.—Born at Bishop Stortford, in 1813,
Archer was apprenticed to a silversmith in Leadenhall Street,
London. His tastes were artistic, and on attaining manhood
he became a sculptor. It is said that his early attempts at
photography, by the calotype method, about 1847, were stimu-
lated by his desire to employ the art to secure mementos of the
productions of his chisel. In September, 1850, Archer's new
process was so far advanced that he communicated it to his
friends, among whom were Dr. H. W. Diamond, Mr. P. W.
Fry, and others, from whom he received much assistance.
Probably Archer did not realize the importance of his dis-
covery, for he did not attempt to patent it; although in 1855
he patented a method of removing the collodion film from
glass by coating it with gutta-percha, an improvement which
had little or no practical value.

So good and complete was Archer's method that in three or
four years it practically displaced both calotype and daguerreo-
type, and reigned supreme from 1855 to 1880. The inventor
took up photography professionally, opening a studio in Great
Russell Street, near the British Museum; but he made no
money by photography, for his brain was too busy in imagin-
ing new things to reap the benefit of that which he had already
accomplished. Among other inventions devised by Archer,
we may name a camera, within which the plates could be de-

veloped and fixed, as well as exposed; a triplet lens; and a useful method of whitening positives on glass by soaking them in mercury bichloride. This was called the "alabastrine process."

Scott-Archer died in May, 1857, and was buried in the London suburban cemetery called Kensal Green. A subscription of £747 was raised for his widow and little children, but, Mrs. Archer dying shortly afterwards, the amount was settled on the children, together with a government pension of £50 per annum, awarded on the ground that their father was "the discoverer of a scientific process of great value to the nation, from which the inventor had reaped little or no benefit."

Outline of the Collodion Process.—The following account is taken from a small book—"Manual of the Collodion Photographic Process"—published by Archer in 1852; a second edition appeared in 1854.

1. Immerse eighty grains of cotton-wool in a mixture of one ounce each of nitric and sulphuric acids; take out after fifteen seconds, and wash thoroughly in running water.

2. Dissolve the pyroxyline so obtained in a mixture of equal parts of sulphuric ether and absolute alcohol. The solution so obtained is ordinary collodion.

3. Add some soluble iodide—usually iodide of potassium—to the collodion. A little potassium bromide may also be added.

4. Pour the iodized collodion on a perfectly clean glass plate, and allow two or three minutes for the film to set.

5. Take the coated plate into the dark-room and immerse it in a bath of silver nitrate (30 grains to every ounce of water) for about a minute. Here a chemical change takes place by which silver iodide is formed in the pores of the collodion.

6. Remove the plate, which is now sensitive to white light, place it in a slide-holder, and expose it in the camera. The time of exposure "may vary from one moment to a quarter of an hour."

7. Take the plate back to the dark-room and develop it by pouring on it a mixture of water, one ounce; acetic acid, one dram; pyrogallic acid, three grains. Archer claims that "the great power shown by pyrogallic acid in bringing out the

latent image was first made known by me in a short description in the May number of *The Chemist* for 1850."

8. Fix the image by soaking the plate "in a strong solution of hyposulphite of soda." At a later period cyanide of potassium was preferred by most operators for this purpose.

Collodion Positives.—When a single picture only was desired, a short exposure was given, and the deposit of metallic silver which forms the image was whitened by soaking the developed plate in mercury bichloride. When a black surface was then placed behind the photograph it stood out on the glass in correct black and white as a positive image. Probably every household has specimens of such collodion positives, of which large numbers were produced between 1854 and 1870. An American improvement consisted in the use of thin plates of black or chocolate enameled iron—ferrotypes, irreverently called tintypes—or sheets of black japanned leather, instead of glass. Itinerant photographers still employ this "positive" method largely, since by it they can complete and hand over their productions to their clients within a few minutes.

For making lantern slides the wet collodion process is still considered one of the best, if not the best method.

Popularization of Photography.—Up to about 1853 a photograph was considered a curiosity; but the introduction and perfection of the collodion process made photography, for the first time, a really popular pursuit. With mistaken ideas as to the ease of the new method, large numbers of amateurs purchased the necessary materials, and, about 1858, the camera became as common an object as the barrel organ!

But with the practice of photography came the sad knowledge that there is no royal road to the taking of good pictures. Although money might be lavishly spent in the purchase of costly apparatus, yet it was soon found that some knowledge of chemistry, and some artistic taste, together with practice in manipulation, and neatness and accuracy in working, were indispensable to success. Moreover, the chemicals employed—more especially the silver nitrate—had ways of marking the apprentice to photography; stains of inky darkness upon the hands and clothes soon earned for the infant science the appellation of the "black art."

Thus the popularity of photography—as an amusement for amateurs—declined almost as rapidly as it had risen. Still some lasting effects of the first photographic boom remaine.l. The Photographic Society of London,* established in 1853, has always exercised a favorable influence on photography in Great Britain; while our two old weekly periodicals, the *Photographic News*, dating from 1858, and the *British Journal of Photography*, 1859 (as a monthly from 1854), have steadily led the way in endeavoring to make photography more and more a science; and in showing that it is something better than a mere mechanical pursuit, or means of getting a livelihood.

Improvements in Lenses.—In 1841, Towson, of Liverpool, pointed out that since in an ordinary or "uncorrected" lens the focus of the chemical rays (as we may call those which produce the principal effect upon the salts of silver) is not the same as the focus of the visual rays, *i. e.*, those by which the image is seen, it is necessary to adjust the distance of the lens from the ground glass, after the picture has been focused, in order to allow for this. Here Professor J. Petzval, an eminent mathematician of Vienna, came to the rescue, and devised a portrait lens which brought all the rays practically to the same focus. This lens was manufactured by Voigtlander, of the same city, and soon acquired a great reputation.

Development of Professional Photography.—Among the earliest daguerreotypists of America were Messrs. John Johnson and A. Wolcott, who worked together. Mr. Wolcott, in order to take portraits more rapidly, devised a camera with a concave mirror instead of a lens, and the plate was placed in the focus of the mirror. In 1840, Johnson came to London, took out a patent for his "reflecting camera," and entered into partnership with the holder of Daguerre's patent, Mr. Beard. They engaged a Mr. Goddard from the Polytechnic Institution as an assistant, and it was found that by using bromine in addition to iodine for sensitizing the silver plates, the time of exposure was reduced from minutes to seconds. At this time, 1841, there were only two photographic establish-

* Title changed to Photographic Society of Great Britain, in 1876.

ments in London, those of Beard and Claudet, but the new art already enjoyed much popularity and their takings were frequently as much as £50 per day.

The census of Great Britain for 1841, does not record photography as an occupation at all; even in 1851, only 51 professional photographers are included; while in the returns for 1881, we find no fewer than 7,614 photographers.

In 1857, professional photography derived considerable benefit from a fancy of the Duke of Parma, who had his portrait gummed on his visiting cards in the place of his name. Disderi, in Paris, court photographer to Napoleon III., pushed the matter, and soon it became the correct thing for every person in society to present his friends with his carte-de-visite.

The patent of Daguerre lapsed in 1853, and as Fox-Talbot was defeated in a lawsuit which he brought, in 1854, against a professional photographer called Laroche, who employed the collodion process (which Talbot claimed as only a modification of his calotype), the field of photography was free to all. Ever since 1854 its history has been one of steady and continued progress.

Some Defects of the Wet Collodion Process.—Of the annoyance and damage caused by the black stains of nitrate of silver we have already spoken; but the odor of the collodion, due to the evaporation of the ether and alcohol which it contained, was also very disagreeable, especially in the small and usually hot rooms in which photographic operations were commonly carried on. Then, in the preparation of the glass plates before they were coated, great care had to be exercised to get a smooth and chemically clean surface; the least scratch, or speck of dust, showed as a defect in the finished picture. The making of collodion was so troublesome a process that it was usually purchased ready made. The bath of silver nitrate was another source of endless trouble; its vagaries fill a large portion of the photographic periodicals of the time; it needed continual care, attention, and renewal. Lastly, the necessity of keeping the surface of the sensitive plate wet during the whole time of exposure, introduced a serious difficulty when it was desired to carry the plates even a small distance; or

when, as in the case of photographing interiors, the neces-
sary exposure extended over a period of several hours.

Some Achievements of the Workers with Collodion.—Al-
though the photographer who has only acquired the art within
the last few years is apt to look upon the earlier processes
which we have now described with the contempt which nat-
urally springs from ignorance, yet it is certain that many of
the wonders of the new photography has been equaled in the
past "for there were giants in those days!" The principal dif-
ference is that the work has now been rendered more easy and
more certain. We glory in the wonderful rapidity of gelatine
dry-plates, but many years ago Breeze, Blanchard and others,
secured upon wet-plates all those surprising effects of breaking
waves and fleeting clouds which many believe have but re-
cently been obtained.

In general work, to take a few examples only, the genre pic-
tures of Rejlander—whose "Ginx's Baby" enjoyed unbounded
popularity—the landscapes of Mudd, England, Bedford, and
Frith, and the portraits of Salomon, Claudet, and Silvy, were
all done with collodion, and will ever remain "hard to beat."

Effect of the Recent Improvements in Photography.—The
main result of the new discoveries in photography which have
signalized the last half dozen years, has been to render it pos-
sible for any person of ordinary intelligence and industry to
produce good or even excellent pictures with far less expendi-
ture of time and labor than was formerly the case; and this
without that soiling of the fingers, clothes, and surroundings,
which in the old days caused every photographer to be a
"marked man."

CHAPTER VI.

COLLODION DRY-PLATES, WITH THE BATH.

Inconvenience of Wet-Plates.—In the earliest photographic processes, the sensitive surfaces employed were exposed in a dry condition to the action of light. The silver chloride paper of Wedgwood and Davy, the bitumenized plates of Niepce, and the iodized silver plates of Daguerre, were all used in a dry or desiccated state.

In the calotype process, devised by Fox-Talbot, where a support of paper coated with silver iodide was employed, the paper might be exposed either in a wet or in a dry state. In the younger Niepce's albumen process on glass, when it was desired to use the plates dry, which was generally the case, the surface, after sensitizing, was washed to free it from the free nitrate of silver, and the plate was then dried by the aid of heat, which coagulated the albumen.

But in the collodion process, as introduced by Scott-Archer, in 1851, it was absolutely necessary that the glass plates coated with collodion containing iodide and nitrate of silver, should be exposed while wet; in fact, as soon as possible after their removal from the bath of silver nitrate solution. Moreover, the exposed plates must be developed as quickly as possible— before the surface has had time to dry.

The chief reason for this is that the silver nitrate crystallizes as the plate dries, and the network of distinctly visible crystals so formed interferes with and spoils the picture. The iodide of silver also becomes insensitive to light when dried in contact with the silver nitrate, combining with it to form iodonitrate of silver.

For this reason the ordinary wet collodion process, though well adapted for the studio, is not so suitable for landscape work or for the requirements of travelers. A heavy equipment has to be carried in the form of tent, nitrate bath, etc.,

and a good supply of water—indispensable for the processes of development and fixing—must be at hand; so that we sometimes read of tremendous exertions incurred by enterprising photographers in carrying barrels of water to a mountain top, where that precious fluid was otherwise unattainable. Again, if the exposure was a very long one, as in the case of dark interiors where several hours were sometimes necessary, the surface of the plate had time to dry, and the picture was then, of course, spoiled for the reasons given above.

Lastly, in very cold weather the solution of silver nitrate froze upon the plate when it was used in the open air, so that out-of door photography during the winter months was all but impossible.

To remedy this defect of the wet collodion process, otherwise so great an improvement on all that had gone before, was the aim of many experimenters in the years which immediately succeeded its introduction in 1851. Of the steps by which success was finally attained, and of the still later workers who caused gelatine to displace collodion, only meagre and unconnected details have been hitherto given. Aided by an earnest study of contemporary literature, it will be our aim to endeavor to supply this defect.

Device for Preventing Evaporation. — Early in 1853, a French photographer, M. A. Girod, proposed * to apply a second plate of glass to the surface of the wet collodion, so as to protect it from the action of the air; the plates were placed together in the dark-slide, the plain glass being next the light. After exposure, the plates were separated, and the collodionized plate developed as usual.

One objection to this plan was the liability to injure the delicate skin of collodion. It was also difficult to apply the second glass plate without including air bubbles; imperfections in the glass itself also had an injurious effect. As an improvement, M. Gaudin suggested the separation of the two glass plates by strips of filter paper around the edges. The plain glass plate would then be removed just prior to exposure. Or,

* In *La Lumière* for March 19th, 1853.

better, the plates might be carried, one above another, in an air-tight box, by which evaporation would be checked. None of these plans, however, were found to be of much practical value; for one thing, they greatly increased the weight of glass which had to be carried.

A Moist Collodion Process.—In the *Philosophical Magazine* for May, 1854, Messrs. John Spiller and William Crookes, names that have since become famous in the annals of chemistry, proposed to keep the collodion *moist* by the use of some deliquescent salt, *i. e.*, some substance which, having a strong affinity for water, would absorb moisture from the air. They tried the nitrates of lime, magnesia, and zinc. The glass plate was collodionized and sensitized in the usual way, and was then immersed in a solution of zinc nitrate and silver nitrate for five minutes. After draining for half an hour on blotting-paper, the plate was ready for use. Such plates remained moist (owing to the hygroscopic nature of the zinc salt), and fit for use for a week or more. They could also be kept for some time after exposure, but before development it was necessary to dip them again into the silver nitrate bath. Subsequently Spiller and Crookes found that nitrate of magnesia acted rather better than nitrate of zinc.

The Honey Process.—In 1854, George Shadbolt and Maxwell-Lyte independently proposed the use of a solution of honey, or of grape sugar, to coat the sensitized plate, which had been previously washed until the greater part of the free nitrate of silver was removed. Before development, the syrup was washed off, and the plate again dipped in the nitrate bath. By this coating with honey the surface of the sensitive plate was kept moist, and crystallization of the remaining silver nitrate was prevented. Plates treated in this way required about double the exposure of ordinary wet plates; but they could be kept for days between sensitizing and exposing; and again between exposing and developing. They were, however, very liable to spots, since particles of dust adhered firmly to the sticky coating.

The Taupenot, or Collodio-Albumen Dry-Plate Process.— A process which found great favor, and which was practiced for many years, was published, in 1855, by the French scien-

tist, Dr. J. M. Taupenot.* It was, in fact, the first dry-plate process of practical utility. As first published, Taupenot's method was to take the collodionized and sensitized plate, pour over it a solution of iodized albumen, and allow it to drain and dry; the plate was then dipped a second time into a silver-nitrate bath, again washed, and finally dried. This double process was thought rather tedious, but the plates so prepared would keep for weeks or months.

It may be remarked that the addition of albumen to the ordinary silver nitrate bath had been previously recommended by Mayall,† the plates being dipped in the mixture, and then washed and dried.

In the collodio-albumen process the film was very apt to slip off the glass during fixing, and Barnes, Hardwich, and others advocated, in 1859, the application of a coating, or substratum, of gelatine, albumen, or india-rubber, which, adhering firmly to the glass surface below and to the collodion above, would hold the latter securely on the plate.

Taupenot's process owed its popularity in England largely to Mr. W. Ackland, who wrote several papers pointing out its advantages. Of the many who practiced it, Mr. James Mudd, of Manchester, obtained perhaps the best results, his landscapes being objects of admiration at many of our exhibitions between 1860 and 1870. The principal, almost the only, fault of the collodio-albumen process, was its slowness. The plates required an exposure about six times longer than wet collodion. Then the plates would not keep for very long periods; at least, they were never so good after six or eight weeks.

The Oxymel Process.—This method of arresting evaporation from the surface of a collodionized plate was described by J. D. Llewelyn in April, 1856. Oxymel is a mixture of vinegar and honey, and plates covered with it were found to retain their good qualities for eight or ten hours. But the exposures were long—about six times more than for ordinary wet collodion plates.

Collodion Plates Kept in Water.—Perhaps the simplest

* *La Lumière*, Sept. 8th, 1855.
† *Journal London Photographic Society*, May 21st, 1855.

way of keeping the collodion "moist" was suggested by H. N. King,* who carried his sensitized plates in a light-tight box filled with distilled water; the weight of the water required was an obvious objection to this plan.

Collodion Dry-Plates.—Mr. G. R. Muirhead, of Glasgow, stated† on the 4th of August, 1854, that "light acts almost as energetically on a dry surface as on a wet, and if a plate be washed well in water (after immersion in the silver bath) to remove all the free nitrate, and allowed to dry, it will remain unaltered for a lengthened period; before developing the plate it must be dipped in the silver bath, as a photograph will not develop without the presence of free nitrate of silver."

But in this discovery Muirhead had been anticipated by M. A. Gaudin, who had declared‡ several months previously, that "the presence of this film (of nitrate of silver) during the exposure is altogether superfluous; it is only useful during the development" of the plate.

Accordingly Gaudin washed his sensitized plates in distilled water, until the silver nitrate upon their surfaces was removed; having thus "suppressed the argentiferous film," the plate was dried by the aid of heat, exposed, again dipped in the nitrate bath, and then developed. In this very suggestive paper the author also points out, that the absence or thinness of the image at the point where the developer is poured on, is due to the liquid sweeping away the free nitrate of silver from that part. He also suggests the use of a solution of white sugar, honey, treacle, etc., which permit in fact the nitrate of silver to dry upon the plate without crystallizing; in this, Gaudin may be said to have anticipated Shadbolt and Lyte.

Early in 1855, Dr. Hill Norris, of Birmingham, described § a dry process in which the sensitive plates were washed, first in distilled water, and then in the usual developing solution of pyrogallic acid, after which they were dried and kept till wanted.

* *Journal London Photographic Society*, Feb. 21st, 1857.
† *Journal Photographic Society*, vol. ii., p. 19.
‡ In *La Lumière* for April 22d and May 27th, 1854.
§ *Journal London Photographic Society*, May 21st, 1855.

The Fothergill Process.—This process was first described by Mr. Thomas Fothergill in the *Times* newspaper early in 1858. It was, in fact, merely the first half of Taupenot's process, the albumen being washed off the sensitized plate, which was then allowed to dry. It was found that notwithstanding this washing, sufficient albumen was retained in the pores of the collodion to answer all necessary purposes. From its simplicity, Fothergill's process was largely practiced between 1857 and 1865, and dry-plates made on this principle were then an article of commerce.

Dry-Plate " Preservatives."—After the publication of Dr. Taupenot's collodion-albumen process in 1855, every few months saw the announcement of some new substance or other, wherewith the sensitive surface of a collodion plate might be covered, so as to enable it to be dried and kept ready for use. We now know that such "preservatives" have a triple function : (1) they fill the pores of the collodion and so give ready access to the developing solution when it is subsequently applied; (2) they protect the silver salt from the action of the atmosphere ; and (3) they assist the action of light by absorbing the bromine or iodine given off from the silver salt during the exposure.

Among the preservatives formerly in use we may name gelatine (Hill-Norris, July, 1856), meta-gelatine (Maxwell-Lyte, February, 1857); golden syrup (J. Sang, April, 1857), gum arabic (A. Johnson, August, 1857), besides brown and white sugar, dextrine, raspberry vinegar, beer, wort, malt, morphine, tea, coffee, tobacco, and many other substances.

Dr. Hill Norris's Collodio-Gelatine Process.—Dr. Norris first laid down the theory that for dry processes a porous collodion was necessary, and that one great function of the preservative coating was to fill up the pores of the collodion while the latter was wet and open. Then, subsequently, when the developer was applied, it passed readily by means of the coating *into* the collodion film. On September 1st, 1856, Dr. Norris took out a patent for the following process, by which pictures may be produced " on perfectly dry and hard collodion films. Having produced in the film the sensitive iodide

of silver, it is immersed in a solution of gum-arabic, or of dextrine, starch, gelatine, albumen, gum-tragacanth, vegetable mucilage, caseine, gluten, or other such like substances, that will, by occupying the pores of the collodion film, prevent its condensation on drying, and retain it in a sensitive and pervious state; the films are then dried, and are ready for exposure to light, or may be kept for any convenient length of time and used as desired." Dry-plates prepared according to this method, or rather, it was supposed, according to a modification of it which was kept secret, were made in large numbers at Birmingham under Dr. Norris's direction. They were perhaps the first dry-plates introduced into commerce, and were largely used between 1856 and 1866. They appear to have had many good qualities, and to have been nearly as rapid as wet plates. A. J. Melhuish writes: * "Having used during the last year or two nearly 2,000 of Dr. Norris' dry gelatine plates, I have never had one negative *spoiled*, and but two or three affected by blistering." It is believed that Dr. Norris discovered the superior sensitiveness of bromide over iodide of silver and that it was bromide of silver which was used in the "Norris" dry-plates.

The Resin Process.—About the year 1856 the Abbé Desprats recommended the introduction of a little resin into the collodion. The glass plates were coated with this resinized collodion, which was then sensitized, and finally well washed and dried. Such plates were found to keep well, but the resin soon caused the silver bath to get out of order. Its useful action on the plate was due to the fact that, being in an extremely fine state of division, it kept the collodion open, and facilitated the entrance of the developer into its pores.

The Tannin Process.—In 1861, Major C. Russell published a small book containing an account of the researches which he had then pursued for nearly five years in dry-plate photography. A second edition appeared in 1863, and an appendix in 1865. It had been known for some time that a wash of gallic or pyrogallic acid over the collodion before drying it,

imparted keeping powers and sensitiveness to dry-plates. Russell found that the substance from which these acids were prepared—*tannin*—was preferable even to them. The process at first published was as follows: " Coat the plate with collodion, and sensitize it as usual ; then wash well; now pour over the surface a solution of tannin, fifteen grains to the ounce of water; lastly, drain and dry."

The Gum-Gallic Process.—The ingredients from which this process derives its name were used by Hardwich in the preparation of dry-plates as early as 1860; but the process with which Mr. Russell Manners Gordon obtained such excellent results was entirely of his own working out, and was first published in the "Photographic News Year-Book" for 1868. The plate was edged with albumen, coated with iodized collodion, and immersed in the nitrate bath for ten minutes. It was then well washed and flowed over with a solution containing gum arabic, sugar candy and gallic acid; the plate being then drained and dried. The exposure required was from four to twenty times that of a wet-plate.

The Albumen Beer-Process.—The early dry-plate workers used to joke each other on a certain " gin-and-water " process, the defect of which was said to be that the liquid would not " keep." Sherry was actually employed with success, while beer was found to be a capital preservative. In 1874, Capt. Abney devised the "albumen-beer process," which was successfully used in that year by the expeditions sent out to study the transit of Venus. He used a very porous collodion, which was poured on the glass plates, then sensitized by immersion in a bath of silver nitrate, and flowed over with a mixture of albumen and (flat) beer. The plate was drained, and then a second mixture, composed of beer with a little pyrogallic acid, was poured over it. It was then dried in the ordinary manner, and was ready for use.

Backing for Dry-Plates.—Dry-plates prepared by the methods we have now described were usually translucent, the light passing freely through the film and being (in part) reflected from the glass behind, thus producing halation. To remedy this, it was usual to " back " the plates with a mixture of burnt sienna and gum-water, or some similar opaque com-

pound. This "backing" was washed off prior to development. At a later date, pieces of black tissue rubbed over with glycerine were placed on the back of the plate for the same purpose, and this is a plan which might still be adopted with profit where the chances of halation are great.

CHAPTER VII.

COLLODION EMULSION.

What is an Emulsion?—The term emulsion is applied to a liquid which holds in suspension a large number of particles of some solid body.

Milk may be considered as the type of an emulsion—the word itself being derived from the Latin *emulgere*, to milk out —since it consists mainly of water in which are suspended innumerable minute particles of fat (cream). The white color of milk, and of most emulsions, is due to the reflection of light from these solid particles.

Early Workers with Emulsions.—Very soon after the discovery of the wet collodion process, it was seen how advantageous it would be if the "bath" of silver nitrate could be dispensed with. In August, 1853, M. A. Gaudin, a French photographer, whose work has hardly received proper recognition, stated in the pages of *La Lumière*, that "the whole future of photography seemed to require a sensitive collodion, which could be preserved in a flask and poured, when required, upon glass or paper; and by the use of which, either at once, or after the lapse of time, positive or negative pictures could be obtained."

This idea must have occurred to many minds; in September, 1861, a London photographer named Bellini, announced* a process for coating glass with a solution of shellac containing iodide, bromide, and lactate of silver; "all that is necessary is to coat a plate with this preparation and expose it in the camera." This process was not a workable one; but next year Captain Dixon and Mr. Samuel Fry attempted to form a company to work a method by which "a preparation is poured upon the plate, whereby an even, homogeneous film is pro-

* *Photographic News*, page 250.

duced, which is sensitive to light." The then editor of the *Photographic News* justly remarked that " we conceive it to be very possible that the germ of a considerable modifi- cation or revolution in the ordinary negative process may spring from this discovery."* From Dixon's patent it appears that he simply added nitrate of silver, dissolved in alcohol, to ordinary iodized collodion. His first results—which appear to have been comparatively accidental—were his best ; and he did not work out the method so as to arrive at any definite formula.

In the same year Gaudin published in *La Lumiere* his method of preparing *photogene*, a name which he ap- plied to " any sensitive compound containing iodide of silver with excess of free nitrate of silver." He writes: " I prepare the collodion photogene by dissolving nitrate of silver in hot alcohol with a few drops of water, and adding this to collodion ; the mixture must be well shaken, and while shaking add from time to time a few drops of iodized collodion." The photogene so prepared was poured upon glass or paper, and was ready for use at once. But Gaudin found that " upon glass the image develops very feebly and super- ficially. The photogene is almost impenetrable to developing agents ; and this is unfortunate, because, but for that, it would realize the long-sought-for dry collodion." The fact is, although Gaudin did not know it, that silver iodide alone does not form a good emulsion unless special precautions are taken ; it clots too rapidly and sinks to the bottom of the collodion.

Sayce and Bolton's Collodion Emulsion Process.—It was on September 9th, 1864, that Messrs. B. J. Sayce and W. B. Bolton, of Liverpool, published † an account of a process which they had then but just devised. They added nitrate of silver to a bromized collodion, thereby forming bromide of silver in the collodion. Plates were coated with this liquid, and then flowed over with tannin, after which they were dried. Improvements, mostly by the authors of the process, quickly followed. The amount of silver was increased, and the pre-

* *Photographic News*, April, 1861, p. 193.

† *British Journal of Photography*.

servative (the tannin) was mixed with the emulsion instead of being added afterwards. From this time we find the words " organifier," or " sensitizer," more frequently used than " preservative," for such substances as tannin, etc. Mr. Sayce, the elder and more experienced of the two workers, retired in 1865 from the practice of photography; but his coadjutor, Mr. Bolton, continued to introduce valuable improvements; thus, in November, 1865, he pointed out the advantages of a small excess of nitrate in the collodion emulsion.

In April, 1870, a well-known American worker, Mr. Carey Lea, recommended the addition of a few drops of aqua regia to the emulsion, the result being that the plates no longer fogged, a defect to which they had previously been liable, especially when a high degree of sensitiveness was aimed at. Capt. Abney has since shown that this introduction of a mineral acid into the emulsion prevents the formation of, or destroys when formed, any oxide or sub-bromide of silver, substances which would inevitably produce fog on the application of the developer.

Many other workers, among whom we may name Col. Stuart-Wortley and Messrs. George Dawson, T. Sutton, W. J. Stillman, J. W. Gough and H. Cooper, added their mites; and an unfortunate paper war was carried on as to the respective claims of B. J. Sayce and W. B. Bolton to be considered the sole, or at all events the principal originator of the process. As the first announcement of the collodion emulsion process was signed by both, it surely ought to be a case of " honors divided."

The Washed Collodion Emulsion Process.—During the first ten years after the introduction of collodion emulsion, the excess of soluble salts was removed by washing the emulsion after it had been poured upon the glass plates. It is true that in 1871 Sutton proposed the use of a " corrected" emulsion, in which the proportions of the bromide and the nitrate were so adjusted as to leave neither in excess, but the practical difficulty of securing this result led to the universal practice of washing the plates after the emulsion had been poured on them.

On January 16th, 1874, Mr. W. B. Bolton showed* that the

* In the *British Journal of Photography.*

emulsion might be washed *before* coating the plates. A collodion emulsion was made in the usual way, and it was then poured into a shallow dish. Here the ether and alcohol soon evaporated, leaving a semi-solid mass behind, which was cut up into pieces and well washed until all the soluble salts were removed. This pellicle was then dried and afterwards redissolved in ether and alcohol, the final result being an emulsion of the pure silver salt in collodion, uncontaminated by the presence of any other substance. Such an emulsion could be kept in bottles for years, and when required for use it was only necessary to melt the emulsion by placing the bottle containing it in hot water, and then to coat the plates and dry them. A "preservative," usually tannin, might be added to the emulsion, or the plates might be flowed over with it after coating and before drying. By this process Gaudin's ideal was attained, and from 1874 to 1880 the "washed collodion emulsion process" found many friends and admirers.

The Beechey Dry-Plates.—In the *British Journal of Photography* for October 1st, 1875, an English clergyman, the Rev. Canon Beechey, described what has been considered by many as the "simplest, easiest, and most uniform preparation of collodion dry-plates"; a fuller account appeared in the "British Journal Photographic Almanac" for 1879. A collodio-bromide emulsion was made in the ordinary way, a few drops of hydrochloric acid being added to produce a little chloride of silver also.

The plates, after being coated, were soaked for a few minutes in flat bitter beer to which pyrogallic acid had been added (thirty grains to one and a half pints), which acted as a "preservative."

Emulsion and dry-plates prepared in this way became an article of commerce; and, indeed, Messrs. Rouch still sell "Beechey Dry-Plates" at half-a-crown per dozen, for making lantern transparencies. For landscape work, an exposure of about one minute with a medium stop was necessary with these Beechey plates.

CHAPTER VIII.

GELATINE EMULSION WITH BROMIDE OF SILVER.

*Nature and Manufacture of Gelatine.**—Gelatine is an
amorphous, brittle, nearly transparent, faintly yellow, tasteless
and inodorous animal substance. It is obtained from the hides
of oxen, skins of calves, spongy parts of horns, etc. Bones,
when boiled, yield one-third their weight of solid gelatine.
Isinglass—or fish-glue—is a form of gelatine obtained from
the swimming-bladder of the sturgeon. Ordinary glue is an
impure form of gelatine; but fairly pure gelatine, such as is
used in the making of jellies, etc., was not manufactured until
the beginning of the present century. In 1844, Cox, of Gor-
gie, near Edinburgh, patented an improved method of making
gelatine; and somewhat later Nelson, of Leamington, Eng-
land; introduced steam as an agent for softening and dissolving
this substance. In 1872 Nelson began to make a specially
pure "photographic gelatine," which has ever since been
largely used. Foreign makers of repute at the present time are
Coignet, of Paris; Heinrich and Drescher, in Germany, and
the "Winterthur" gelatine, of Switzerland. The maker of
gelatine uses largely the parings and cuttings of hides from
the tan-yard, ears of oxen and sheep, skins of rabbits, hares,
dogs, cats, etc., old gloves, parchment, etc. These are steeped
in lime-water, washed, and then bleached with sulphurous
acid, and washed again. The gelatine is then extracted by
means of steam, and run on marble slabs to set. It is next cut
up and washed, redissolved, and, lastly, dried in thin sheets on
nets. In the cutting it is the practice of some workmen to
lubricate the knives; but this ought to be rigorously avoided,
if the gelatine is to be used for photographic purposes, since the

* See Davidowsky's "Practical Treatise on Glue, Gelatine, etc.," 8vo,
297 pp. ; illustrated. Baird & Co., Philadelphia.

fatty matter thus introduced causes "pits" or spots in the plates.

Gelatine is, without doubt, a "sensitizer." If we remove silver bromide from one-half of a gelatine emulsion and mix it with collodion, the collodion emulsion will not be nearly so sensitive to light as the remaining gelatine emulsion; the precise cause of this sensitizing action is not certainly known. For one thing, the gelatine wraps round and grips firmly every particle of silver bromide, thus allowing us to use a stronger developer without danger of fogging the plate than we can do in the case of collodion. But it has also been shown by the German chemist, Knopp, that gelatine is capable of combining with bromine, and it thus assists the action of light in decomposing the silver bromide by attracting and uniting with the bromine given off from the silver salt under the action of light.

Gelatine is insoluble in cold water, in which, however, it swells considerably, increasing in weight. The jelly so formed liquefies immediately when its temperature is raised to about 100 deg. F.

Early Workers with Gelatine.—The introduction of gelatine, as a means whereby the sensitive salts of silver could be retained upon a plane surface of glass or paper, followed quickly upon the publication of the "albumen-on-glass" process, discovered by Niepce de St. Victor, in 1848. In Gustave Le Gray's book—translated into English in 1850—he mentions the use of gelatine for such a purpose, the support being coated with iodized gelatine, dried, and then sensitized by immersion in a bath of silver nitrate in the same way as collodion. The gelatine, however, was found to swell or even dissolve in the silver bath. In Germany, Dr. Halleur obtained beautiful images on similarly prepared plates, but they quickly disappeared, a result probably due to the acetic acid (in which gelatine is soluble), then used as an ingredient of the developer.

In 1854, "E. R., of Tavistock," published * full and clear directions for the use of "Swinburne's patent isinglass" (a variety of gelatine) as a substitute for collodion, the exposure

required being thirty-five seconds with a diaphragm or "stop" whose aperture was one twenty-fourth of the focal length of the lens employed.

In 1861, Gaudin used gelatine as one of the substances with which he prepared his "photogene"—the forerunner of emulsion photography.

Poitevin, who had long used gelatine in his printing process, showed, in 1862, how "dry-plates with the bath" could be prepared with it. A curious feature of this method was that bichromate of potash was mixed with the gelatine, after which the plates, coated with the mixture, were exposed to light; "then the bichromate reacts upon the gelatine, and prevents it from creasing * in the water during the subsequent operations."

In 1865, W. H. Smith took out a patent for impregnating the surfaces of wood, canvas, silk, glass, etc., with some resinous solution which would fill up the pores, and then coating the prepared surface with "collodion or gelatine, or any gelatinous substance—mixed with spirits of wine and nitrate of silver, the nitrate of silver being mixed with a chloride, a bromide or an iodide. After exposure in the camera a toning solution is employed."

An Early Experiment with Gelatino-Bromide.—In January, 1868, Mr. W. H. Harrison wrote a short article on "The Philosophy of Dry-Plates," † in which he starts by asking a question that we have not yet been able to fully answer: "Why should one organic solution give a rapid plate, and another a slow one?" In experimenting on this subject he made a very weak solution of gelatine in which a "little bromide and iodide of cadmium were dissolved, after which some nitrate of silver was added in the dark. In fact, I wanted to have a solution which would give a good dry-plate, by simply coating a sheet of glass with it." Plates coated with this emulsion were dried and exposed in the camera, and then developed by the alkaline method. "The picture came out very rapidly, and was of great intensity, but the rough and uneven surface

* Or, as we should say, "frilling."

† *British Journal of Photography*, January 17th, 1868.

of the film made it worthless." When a stronger solution of gelatine was used, no pictures could be obtained, a result possibly due to the weakness of the developer then used. This article of Mr. Harrison's appears not to have been noticed by writers on the discovery of the gelatino-bromide process, of which it really contains the germ.

Thomas Sutton has a Theory.—From 1855 to 1870 there were few more active among the workers and writers on photography than Thomas Sutton. He was rather too fond of theorizing, and was apt to believe that, because he could trace out the steps of a process in his "mind's eye," it must, therefore, be a practical success. Still, the following remarks, taken from one of his contributions to the *British Journal of Photography*,[*] show that his ideas upon gelatine emulsion were in advance of the time. " There is something very ingenious and promising in M. Gaudin's gelatine emulsion. Used with bromide of silver instead of iodide, it might turn out something grand. The objection to collodion is that, when it is allowed to get dry upon the plate without having been wetted, it dries to an almost impenetrable skin, which the developer has scarcely any power of entering, so that the image is thin and superficial. This would not occur with a gelatine film. There do not seem to be any difficulties in spreading it as there are in spreading albumen, for it is applied hot, and quickly sets. Oxide of zinc gives a structureless and homogeneous film when made into an emulsion with gelatine; bromide of silver ought to do the same. A gelatino-bromide emulsion, slightly alkaline, would be exquisitely sensitive without any free nitrate; and tannin, with the aid of the alkali in the film, would, no doubt, develop it, perhaps to sufficient density, without silver. A great advantage would be that the film could be composed of a capital organifier through its entire substance, instead of having a mere layer of organifier upon the surface. The process is well worth trying; it seems to be right in theory throughout."

Sutton then goes on to describe Gaudin's gelatino-iodide process, after which comes the following paragraph which

[*] July 14th, 1881.

reads, to us, amusingly enough : " A tourist, employing the
above process, would have his bromide of silver emulsion ready
made in a semi-solid state, resembling *blanc-mange ;* he would
melt it by putting the bottle containing it into boiling water ;
he would then coat his plates at night for the next day, and
put them at once into the plate-box to get dry. No washing
of the plates would be required, and that is one grand feature
of the process. The next morning he would hang a yellow
curtain before his window, and put them into the dark-slides,
developing them at night. He would have no dangerous, ex-
plosive, strong-smelling, unhealthy collodion to carry about
with him on his travels, and he might pack in a very small
compass enough chemicals in a dry state to last him for a tour
round the world. What a blessing it would be to be indepen-
dent of collodion, and at the same time not to have to trust to
the keeping qualities of dry-plates !

" It may turn out that I have done well in digging up this
old process of M. Alexis Gaudin, whose name be exalted as
the author of collodion emulsions and photogenes ! "

Sutton died shortly after writing the above note, but we can
imagine how enthusiastically he would have welcomed the ful-
fillment of all his hopes—and more, in our modern gelatino-
bromide plates which *will* " keep," and whose exquisite sen-
sitiveness is beyond everything that even he imagined.

*Dr. R. L. Maddox makes Gelatino-Bromide of Silver
Emulsion.*—In the autumn of 1871, Dr. Maddox—so well
known for his work in photo-micrography—published in the
British Journal of Photography * " An Experiment with
Gelatino-bromide." Thirty grains of gelatine were swelled in
cold water, and then dissolved by heat, four drams of pure
water and two drops of aqua regia being added.

To this solution eight grains of cadmium bromide and fif-
teen grains of silver nitrate were added, forming a fine milky
emulsion of silver bromide. Without further treatment this
was spread upon glass plates and dried. The plates were
tested by exposing them beneath negatives, and gave a faint
but clear image when developed with a plain solution of pyro-

* September 8th, 1871, p. 422.

gallic acid; intensification with pyro and nitrate of silver followed.

Plates fumed with ammonia fogged when treated with pyro-gallic acid. The gelatine emulsion was also used to coat paper with very fair results. In conclusion, Dr. Maddox writes: "As there will be no chance of my being able to continue these experiments, they are placed in their crude state before the readers of the *Journal*, and may eventually receive correction and improvement under abler hands. So far as can be judged, the process seems quite worth more carefully conducted experiments, and, if found advantageous, adds another handle to the photographer's wheel."

With our present knowledge it is easy to see why Dr. Maddox did not obtain complete success. His emulsion would contain, in addition to the silver bromide, silver nitrate, sodium nitrate and nitric acid (from the *aqua regia*). The presence of the free silver nitrate was the reason why it was possible to develop the plates with plain pyrogallic acid; while the nitric acid acted as a restrainer, and caused the plates to be very slow. By fuming with ammonia the nitric acid was neutralized, but the plates then fogged, because the free silver nitrate was reduced all over the plate by the developer in the absence of any restrainer.

CHAPTER IX.

INTRODUCTION OF GELATINO-BROMIDE EMULSION AS AN ARTICLE OF COMMERCE BY BURGESS AND BY KENNETT.

Burgess Advertises Gelatine Emulsion in 1873.—We have now seen that, between 1868 and 1871, three men—Harrison, Sutton and Maddox—had clearly recognized the *possibilities* of gelatino-bromide emulsion; while two of them—Harrison and Maddox—had actually prepared such an emulsion, with—for a first experiment—a marked degree of success. None of these three men, however, followed up their work, and it seems to have attracted little or no notice.

At least one worker, however, took the hint, and in the pages of the English trade journals for July, 1873,* the following advertisement appeared :

" Mr. J. Burgess begs to announce that as the result of innumerable experiments he has made an *important photographic discovery*, which enables him to prepare dry-plates equal in sensitiveness and superior in many respects to the best wet-plates, and that by simply pouring an emulsion (prepared by an entirely new and original method) on the glass and allowing it to dry without any washing or the application of any preservative; thus saving an immense amount of trouble and expense, and what is more important still, securing films of absolute uniformity, of good keeping qualities, and up to the highest standard of excellence.

" In order that any one may test the truth of the above statement, a four-ounce bottle of the emulsion, sufficient to coat four or five dozen quarter plates, will be sent, post free, for 3s.; and when the new method has been thoroughly tested, if the subscribers are willing to pay one guinea each, a pamphlet will be printed giving an account of the experiments which have

* The exact date is July 18th, 1873.

been tried, and the formula by which the results above described have been realized. Address Mr. J. Burgess, Artist, 207 Queen's Road, Peckham (London)."

Mr. Burgess did not publish, or make known in any way the details of his process, and unfortunately it did not prove a commercial success. But the following quotations from an editorial article * will show its real nature—it was without doubt a gelatino-bromide emulsion:

"We obtained samples and have given the process a trial. Instead of collodion a colloidal substance, without doubt gelatine, is used; and the sensitive material, which we assume to be bromide of silver, is introduced in such a way as to necessitate no washing. The method of preparing a plate is extremely simple. The emulsion, after being slightly warmed, is merely poured upon the glass and allowed to dry, and—that is all. In exposing, we adhered to the instructions given, viz.: that the exposure should be precisely the same as for a wet collodion plate. On the application of the developer (alkaline pyro), the picture rapidly made its appearance, every detail being visible."

In the next number of the same periodical, the gentleman who wrote under the title of "A Peripatetic Photographer," made the following remarks:

"It appears that a new negative emulsion process has been discovered by Mr. Burgess, in which collodion is displaced by gelatine. This is undoubtedly a very great variation in the existing state of emulsion matters, and at first sight it seems to be an improvement. One has heard so much about the vexed questions in collodion emulsions, the difficulty of getting the right kind of pyroxyline, and the impossibility of succeeding unless it be obtained; the difficulty of determining whether a little silver or a little bromide is the correct thing to have in excess; whether the organifier or preservative should consist of gum, tea, coffee, tannin, salicine, cochineal, or gallic acid, and so forth; that one is glad to try a process in which pyroxyline is not, in which there is neither free bromide or free nitrate, but only the emulsified bromide of silver, and in which

* *British Journal of Photography*, July 25th, 1873.

preservatives and organifiers are rendered of no avail because the whole substance of the film itself is organic. . . . The simplicity of the Burgess process is a charming feature. The emulsion is poured over the clean glass plate and, when dry, it is fit for use. There is no substratum, no washing, and no preservative; while over and above all, the sensitiveness is said to be equal to that of wet collodion, which if true, means that plates prepared by the gelatino-bromide process may be used in the studio for the purposes of every-day portraiture."

The objections at this time to the introduction of gelatine emulsion were the "necessity for liquefying the gelatine before it could be used; the equal necessity for laying down each plate in a carefully level position until the film set, and the long time the film took to dry."

In a letter from Mr. Burgess himself* he states that "the weak point of the gelatino-bromide emulsion is its liability to decompose, as I have found out to my cost lately. In a moderate temperature it will keep for weeks; but in spite of all the antiseptics I am acquainted with, it will ferment if the thermometer rises above 70 deg. Fahr. I have, therefore, determined to confine myself to the making of dry-plates, which will keep any time."

In accordance with this resolve, the first advertisement of "gelatino-bromide dry-plates" appeared on August 29th, 1873, the price being half a crown per dozen for quarter plates.

But the time was not ripe for so great a revolution; Burgess's process was not—could hardly be—perfect, and the result was a lack of commercial success which meant—for the time—failure. But Mr. Burgess never abandoned his belief in gelatine, and in 1880 he wrote, for Messrs. W. T. Morgan & Co., of Greenwich, an anonymous pamphlet, "The Argentic Gelatino-Bromide Worker's Guide," which was the first book devoted wholly to that subject.

Removal of Extraneous Substances from the Gelatine Emulsion.—In the autumn of 1873, a writer who took for his *nom de plume* "Ostendo non Ostento," contributed a formula (the first which contains alcohol), for the preparation of gelatine

* *British Journal of Photography*, August 15th, 1873.

emulsion to the pages of the *British Journal of Photography*,* which was the first formula published since that of Dr. Maddox in 1871. But neither of these workers stated the necessity for the removal from the emulsion of the extraneous salts formed by the combination of the chemicals employed.

The first photographer to point out publicly† the need for the removal of all soluble matter from the emulsion was Mr. J. King, of the Bombay Civil Service, who *dialyzed* his emulsion, *i. e.*, placed it in a vessel with a bottom of vegetable parchment or bladder; the whole being half immersed in a large vessel of pure water. Under such circumstances the soluble salts contained in the emulsion pass outwards through the parchment, etc., to mingle with the water. This process was well known to chemists, but it had not before been employed in photography. The editor adds: "The negatives sent by Mr. King, illustrative of his paper, are singularly faultless."

Curiously enough we find side by side with King's communication, a short letter from J. Johnston, in which two very important points are included. The first of these is a direction to use an excess of the cadmium or other soluble bromide in making the emulsion (previous workers had used an excess of silver nitrate), and the second to "let it stand till cold, cut in slices with a piece of thin glass, and wash in distilled water to remove the excess of bromide." This way of washing, or a modification of it, has ever since been employed; it is far simpler and more effective than dialysis.

Kennett's Pellicle.—Burgess's experiments with gelatine emulsion caused Mr. R. Kennett, an amateur residing in Maddock Street, London, to again turn his attention to the subject (it seems that he had experimented with gelatine some years previously). To remedy the grave defect experienced by Burgess, viz., that the finished emulsion would not " keep," Kennett took out the following patent in November, 1873 :

" ABRIDGMENT OF SPECIFICATION OF PATENT :

" A. D. 1873, NOVEMBER 20, NO. 3782.

" A 'substance to be used instead of collodion and other emulsions for photographic purposes.'

* October 3d, 1873.
† *British Journal of Photography*, November 14th, 1873.

" This substance is produced, for use, in a dry or solid condition, and will keep good for any length of time.

" The compound essentially consists of an aqueous solution of gelatine, together with a bromide, chloride, or iodide ; and nitrate of silver.

" The compound is cleared of certain salts, which are formed during the mixing, and then dried. These processes must be conducted in non-actinic light.

" The bromides, chlorides or iodides that may be used are those of potassium, cadmium or ammonium. When the compound is mixed and thoroughly incorporated, it contains a free bromide and nitrate of potash ; these are removed or eliminated by pouring the compound into a dish, letting it cool, and cutting into small strips which are washed with many changes of water until all the free salts are dissolved out. The subsequent drying process is accomplished by heating the compound in flat dishes, until it is reduced to a thick paste. When cold, it is stripped from the dishes and placed in suitable frames in a drying-closet in which a circulation of dry air is maintained."

It will be noticed that Kennett's patent is not, as has been stated, for the whole process of gelatino-bromide emulsion making, *that* had been previously published and could not be patented, but for a *method of preserving such an emulsion in a dry and solid state.* To the dried emulsion prepared according to the patent, Kennett applied the name of *pellicle ;* when required for use it was only necessary to dissolve this pellicle in water and coat the glass plates with it.

The following contemporary advertisements are interesting :

" NOTICE.—R. Kennett is now issuing his patent sensitized gelatino-pellicle, in packets containing sufficient to make two, four or six ounces of emulsion, with full instructions for use at the following prices : One, two, and three shillings."*

A complaint against this pellicle was that it gave very thin images, so that we find in a somewhat later advertisement the following addition :

" A special pellicle for obtaining extra density at 1s. 6d., 3s. and 4s. 6d."

At a later date Kennett prepared plates for sale as well as pellicle, and in April, 1876, his advertisement runs :

" R. K. is now prepared with his rapid pellicle plates to photograph interiors of mines, caverns, or any other subject that has hitherto been an impossibility with any other process, wet or dry. R. K.'s

* From the trade journals for March, 1874.

latest improvement in his plates admits of greater latitude of exposure, gives more density and brighter shadows, without in the least interfering with their now universally acknowledged wonderful and unprecedented rapidity."

During the years 1874–77 Kennett tried hard to introduce his gelatine pellicle and dry-plates. But photographers seem then to have been a terribly conservative body, and hard to move, and he failed in his endeavor to introduce these articles into general practice. The following note from an amateur of the first rank, the Rev. H. J. Palmer, will, however, give some idea of their capabilities : *

" As regards exposure, it should be borne in mind that Kennett's *rapid* pellicle and plates are, with good light, really instantaneous. Nothing can surpass the cloud, wave, and street views taken with this preparation ; and for babies' portraits it is simply perfection itself. The *ordinary* pellicle is much slower, requiring rather more than half the exposure requisite for a wet-plate."

But at that time all was in vain. The very rapidity of the Kennett plates was one cause of their commercial failure. The workers of ten or twelve years back could not, generally speaking, be brought to believe that a dry-plate could possibly be more rapid than the collodion wet-plates which they were so accustomed to manipulate ; and Kennett complained bitterly that the purchasers of his emulsion *would* over-expose immensely, and then blame the plates for fog and for yielding thin images. Moreover, the amount of yellow light by which the dark-rooms were then illuminated was in most cases of itself sufficient to " fog " these sensitive gelatine plates.

Processes Worked in 1877.—At the excellent exhibition of photographs held in Edinburgh, under the auspices of the local photographic society in 1876–77, there were 719 pictures from negatives taken by the wet process, as against 105 dry-plate pictures.

The latter were by the following processes :

Fothergill	15
Gum-gallic	8
Collodio-albumen	22

* *British Journal of Photography*, March 10th, 1876.

" Dry-plates " 20
Warnerke's tissue....... 3
Beer and albumen............................. 15
Coffee.. 9
Emulsion ... 13

Whether any of the "emulsion" plates were gelatino-
bromide we do not know; but in any case this summary of
the pictures contributed to one of the most popular exhibitions
ever held, shows that up to that time, only some ten years ago,
the gelatine process was practically not used at all.

Other Pioneers of Gelatino-Bromide.—The pages of the
English trade journals from 1873 to 1877 contain many useful
suggestions and improvements from one or other of a race of
experimentalists which then flourished, a race which appears,
alas! to be dying out.

In December, 1873, E. W. Foxlee pointed out the value of
alcohol as a preservative in gelatine emulsion, showing that it
enabled gelatinous solutions to be kept for a long time without
undergoing decomposition; its use also caused the plates to set
and dry more rapidly.

Mr. F. Wratten, in August, 1877, showed that the gelatine
along with the silver bromide could be precipitated by adding
alcohol to the solution containing it, leaving behind in the
water all the soluble salts. By this method the necessity for
dialysis or washing could be obviated.

In the "British Journal Almanac" for 1874, Mr. W. B.
Bolton showed how to form the emulsion in a small portion of
the gelatine only, the remainder being added at the close of
the operation. In this way the retarding action of the viscid
gelatine was avoided. At a later period this method was
found very useful.

Of other workers about this time (1873–77) we can only
name Messrs. P. Mawdsley, H. B. Berkeley, J. W. Gough,
Col. Stuart Wortley, and the anonymous contributors, "Ama-
teur," "Franklin," "F. S. K.," and "L. S. D."

CHAPTER X.

GELATINE DISPLACES COLLODION.

Researches of Stas.—M. J. S. Stas, the famous Belgian chemist, published in 1874 * certain "Researches on Chloride and Bromide of Silver," in which he pointed out that the latter substance can exist in at least six well-marked physical states, each state having properties peculiar to itself. These researches by Stas contain the key to our present system of obtaining that exquisite sensitiveness to light in bromide of silver which has of late years effected a practical revolution in photography. But in 1874 the discovery passed unnoticed. Stas was no photographer; and if any photographer studied his paper—which is doubtful—it did not strike him that here was the germ of a process which might surpass all that had gone before. The following translation includes the (to photographers) most interesting portion of Stas's paper:

" *Modifications of Silver Bromide.*—This bromide assumes a large number of physical states of different appearance :

(1.) The white flaky state. }
(2.) The yellow flaky state. }
(3.) An intense-yellow powdery state. }
(4.) A pearly-white powdery state. }
(5.) A yellowish-white granular state.
(6.) A pure intense-yellow crystallized or melted state.

" The white and yellow flaky forms (1 and 2) are produced by mixing cold aqueous solutions of any suitable silver salt with hydrobromic acid or some soluble bromide.

" These two forms may be converted into the powdery or pulverulent modifications (3 and 4) by shaking up well with water. When we pour either the flaky or the powdery bromide of silver into boiling water, it is changed instantly into a very fine powder, which is the granular bromide (No. 5). This may be produced directly, by adding to a boiling solution of silver nitrate (one part to 1,000 of water) a sufficient quantity, also boil-

* *Annales de Chimie.* Fifth Series, vol. iii., p. 289.

ing, of a very weak solution of ammonium bromide. The granular powder resulting from the breaking up of the flakes, is of a dull yellowish-white, while that which is produced by the transformation of the pulverulent variety, or which is formed with the aid of very weak solutions, is of a *shining*-yellowish-white. Under the influence of a boiling, prolonged for several days (the water being constantly replaced), the dull granular bromide is modified; it becomes more and more divided to the point of remaining completely in suspension, and rendering the water white. The suspended bromide presents, in this case, a shining reflection, and is not deposited for a considerable length of time. Separated from the liquid it is of a pearly-white. The pearly bromide becomes a pure intense-yellow by contact with a concentrated solution of ammonium bromide. This change is, so to speak, instantaneous.

" The granular bromide, either dull or shining, and the pearly-white modification of it, resulting from the action of boiling water on the first two, are the most sensitive substances to light with which I am acquainted.

" It is sufficient to boil them for two or three seconds in water over the flame of a Bunsen burner, burning with excess of air, to cause them to blacken. Because of this extreme liability to change, these experiments would not have been possible if they had not been carried on with exceptional precautions.

"Thus the production of the granular bromide, and its change into the pearly-white bromide, were effected in an apparatus which admitted no light. The manipulation of these bodies took place in the dark, and they were examined in a yellow or in a diffused light.

"The pearly-white bromide passes by fusion into the pure intense-yellow state."

Thus, thirteen years ago, Stas discovered and made known that "the most sensitive substance to light" could be obtained by the action of heat upon silver bromide. Yet his discovery fell on barren (photographic) ground, and it was not till 1879 that Monckhoven showed how this work of Stas explained the results obtained by Bennett and others.

Certainly every photographer ought to study chemistry.

Bennett obtains Great Sensitiveness by " Stewing " the Emulsion.—The report of a meeting of the South London Photographic Society on March 7th, 1878, states that "a number of gelatine negatives were exhibited by Mr. Bennett, one of them being an interior of a room, taken by ordinary gaslight, the exposure being one hour "; others were "Boat scene on river, exposure by drop-shutter—say twentieth of a second, and " River scene, exposure four seconds," etc. The experts who examined these negatives considered them sufficiently

surprising, and a general appeal was made to Mr. Charles Bennett—an amateur photographer and member of the well-known firm of London hatters—to publish the process by which he had obtained such (for that time) marvelous results. It is greatly to Mr. Bennett's honor that he at once acceded to this request, and gave to the photographic world on March 29th, 1878,* the details of a method which was destined to revolutionize our mode of working. When the process was studied, the essential point was seen to be the use of *heat*. The different solutions were to be made at a temperature of 90 degrees (Fahrenheit), and, after mixing, the temperature of the emulsion was to be maintained at 90 deg. (by placing the bottle containing it in a vessel of hot water) "for two, four or seven days, according to rapidity required." During this slow and long-continued heating, the silver bromide gradually assumed the "granular" state of Stas, and became exquisitely sensitive to light. Bennett says, "if washed after two days, the emulsion is rapid and dense; in four days, more rapid and less dense—quick enough for any drop-shutter known; with some that I kept for seven days, with drop-shutter and dull February morning, pebbles close to the camera were perfectly exposed. The negative was thin under ammonia, but bore intensifying to any extent."

The commercial importance of Mr. Bennett's discovery was soon seen, and the trade journals for April of the same year contain advertisements from Peter Mawdsley, of the Liverpool Dry-Plate Company, of "Bennett Plates" at three shillings per dozen (¼-plates), and from Messrs. Wratten & Wainright, of the "London Gelatine Dry-Plates and Pellicle," the latter firm at the same time offering collodion emulsion for sale, the two processes thus overlapping.

Gelatine, however, now soon beat collodion out of the field, although the years 1878–80 must be considered years of transition.

Boiling the Emulsion.—In a remarkable communication to the Photographic Society of Great Britain in 1876,† Lieut.-

* See *British Journal of Photography*.

† Reprinted, *British Journal of Photography*, June 30th, 1876.

Col. Stuart Wortley describes the preparation of a gelatine emulsion at a temperature of 180 deg. Fahr., adding, "you will notice that I make a considerable alteration from any instructions that have hitherto been given for the preparation of a gelatine emulsion, as I work at an exceedingly high temperature with the object of forming my emulsion at once, instead of spreading the formation over many hours, as, I believe, other workers do. I get the most perfect films by this method of working, and I am certain that the above temperature has no injurious effect whatever on the gelatine." The only reason we can think of why Col. Wortley did not attain complete success with this method was that he did not maintain the high temperature for a sufficient length of time; he says he allowed the bottle containing the emulsion to stand "for a quarter of an hour in the hot water," which would hardly be long enough at 180 degrees to permit the conversion of the bromide of silver into the sensitive "granular" molecular state.

After general attention had been drawn to the gelatino-bromide process in the spring of 1878 by Bennett's remarkable work, it was soon found that the prolonged emulsification required in his method—stewing for seven days at 90 deg.—was not only very tedious and troublesome, but that—more especially in summer—it produced other evils, especially the decomposition of a part or the whole of the gelatine. Bearing Stuart Wortley's experience in mind, it was not difficult to see that a possible remedy might be found in cooking, or digesting the gelatine for a shorter time, but at a much higher temperature. This seems to have been done by several workers, but it was first publicly announced by Mr. Geo. Mansfield at a meeting of the Photographic Society of Ireland, in August, 1879,* who "drew attention to the fact that the long and troublesome process of digestion might be obviated by forming the bromide of silver in a very weak solution of the gelatine, which was then *boiled* for about ten minutes, the remainder of the complement of gelatine in the formula being added when the first solution had cooled down to about 100 deg. F."

* *British Journal of Photography* for August 22d, 1879.

The other point here recommended—to emulsify the silver-bromide in a small portion of the gelatine only, the remainder being added *after* the cooking—was a repetition of the advice given by W. B. Bolton in 1874; it is the plan now generally adopted.

In May, 1879, Captain Abney, to use his own words, "showed that a good emulsion might be formed by precipitating silver bromide by dropping a solution of a soluble bromide into a dilute solution of silver nitrate in water and glycerine. The supernatant liquid was decanted, and after two or three washings with water, the precipitate was mixed with the proper amount of gelatine." The object of this method was to save the trouble of washing the emulsion.

In connection with this note, it is curious to turn back to a paper written by Thomas Sutton, in February, 1874,* where he writes:

"Mix aqueous solutions of silver nitrate and potassium bromide. White silver bromide will be immediately formed and quickly precipitated. Wash the precipitate repeatedly in water in order to remove the potash nitrate, etc. . . . Mix the dry silver bromide with a little glycerine and add to it a hot solution of gelatine."

It will be seen that the two methods are nearly identical. But, alas! Sutton only asks "Why not do this?" He did not actually try the experiment, or he might perhaps have anticipated Abney by five years.

Researches of Monckhoven.—Dr. D. von Monckhoven, of Ghent, born 1834, died 1882, was an excellent chemist and good "all-round" man of science, who devoted himself chiefly to the scientific side of photography. His "General Treatise on Photography" (1863), and "Photographic Optics" (1868), were leading books in their day, and are still useful. His solar enlarging apparatus (1864) is well known, and for many years he carried on a large business in Belgium for the manufacture of carbon tissue, and afterwards of dry-plates.

We have seen that in the ordinary methods of preparing a gelatine emulsion, a great deal of washing is necessary in order

to remove the superfluous salts. When Monckhoven tried this plan he found that "the water of our good city of Ghent is so chalky—caused by the nature of the soil—that I was obliged to find some method of doing away with washing my emulsions." The plan which he hit upon* was to mix with the fluid gelatine, first, carbonate of silver, and then hydrobromic acid, in the precise quantities in which they would combine chemically with one another. The result of their interaction was the formation of silver bromide (which remained suspended in the gelatine), carbonic acid gas which escaped, and water which was harmless.

Owing, however, to the practical difficulties of the process, which required a skilled chemist to carry it out successfully, and the expense of the ingredients, this method was never employed commercially.

Monckhoven uses Ammonia to Obtain a Sensitive Gelatine Emulsion without the Aid of Heat.—In the same paper in which Monckhoven published the method described above, he stated that he had obtained the sensitive green form of silver-bromide by the addition of ammonia, and without the aid of heat. In an admirable lecture, delivered in October, 1879,† before the Belgian Photographic Association, after describing the formation of an emulsion in the ordinary way by the addition of silver nitrate to a gelatinous solution of ammonium bromide, Monckhoven adds: "Now pour in the pure ammonia and shake up well the solution. The ammonia exercises quite a special action here; its effect is to render the emulsion ready to be used in a few minutes; or, if great sensitiveness be required, it can be obtained in a few hours instead of days, and thus decomposition of the gelatine is avoided."

Some remarks in the same lecture on one of the most frequent causes of failure in out-door work are so valuable that we reproduce them also. "I am certain that I shall not make a great mistake in saying that scarcely one dark-slide of a camera protects the plate as it ought to do. Light enters, especially

* Monckhoven's paper, read before the Photographic Society of France, in August, 1879, was reprinted in the *British Journal of Photography* for August 8th of the same year.

† Reprinted *British Journal of Photography*, October 17th, 1879.

when the shutter of the slide is pulled out to expose the plate. I have frequently proved this in the following manner: I have exposed a plate in the camera without taking the cap off the lens; and in developing, the entire plate has been fogged. You must also make certain that light does not enter through the holes of the Waterhouse diaphragms; nor round the ring upon which the lens is screwed.* I am accustomed in the open air to completely envelope my camera with a large focusing cloth, allowing only the lens to protrude. I even open the dark-slide under this cloth. . . . When I first began my experiments on gelatino-bromide, I could obtain nothing but fogged plates. I wrote to the maker, and he informed me that the cause of my failure was owing either to the red glass of my dark-room, or the state of my dark-slide. I reglazed my window with proper glass, and overhauled my dark-slides. As soon as I took these precautions I had no more trouble with fog."

Monckhoven's "ammonia method" of preparing emulsion at once came into use commercially, and is employed by many manufacturers at the present day. Plates prepared in this way do not, however, retain their good qualities so long as those coated with emulsion which has been simply boiled.

* Nor round the cap of the lens. Look for these defects in bright sunshine, by removing the focusing glass, and then putting head under focusing-cloth; lastly, remove lens and look through lens aperture at dark slide.—W. J. H.

CHAPTER XI.

HISTORY OF PHOTOGRAPHIC PRINTING PROCESSES.

Copying by Light introduced by Wedgwood and Davy.—
The first successful experiments in photography were those in
which copies of opaque or semi-opaque objects were obtained
by placing them upon sensitive paper and exposing the whole
to light.　The parts of the paper not protected from the light
were blackened by it, and when the object was removed its
position and outline were shown in white upon a black ground.
Such a process was, of course, only suitable for flat and thin
bodies, as plants, engravings, etc. ; and those of varying degrees
of opacity gave the best results, because a similar gradation of
shade was obtained in the copies.　As a sensitive surface, Schulze
used a mixture of chalk and silver nitrate in 1727, and Thomas
Wedgwood silver nitrate spread upon paper or leather in 1795 ;
Davy in 1802 found that silver chloride gave better results than
silver-nitrate.

Photogenic Drawing. — The first person to introduce a
photographic copying process of real value was Fox-Talbot.
He commenced his experiments, it appears, in 1834, using sil-
ver nitrate upon paper ; but, soon discovering that silver
chloride mixed with a little silver nitrate was far more sensi-
tive to light than either of these substances alone, he employed
it with great success for copying purposes, and even, as we have
described in a former chapter, succeeded in obtaining pictures
within a camera by its aid.　These camera-pictures, however,
were *printed right out*, by the action of light, and this caused
the exposures to be very long—from half an hour to an hour.
It was not till Talbot discovered a method of *development* (in
1841) that his process became a practical success as far as tak-
ing pictures in the camera was concerned.

To this copying process upon paper coated with certain salts
of silver, Talbot applied the name of " photogenic drawing,"

and the term might well be retained for this still useful method of copying natural objects by super-position. In the first description of his process, Talbot writes :* " I dip superfine writing paper in a weak solution of common salt, and wipe it dry. I then spread a solution of nitrate of silver (60 grains to the ounce) on one surface only, and dry it at the fire. By alternately washing the paper with salt and with silver, and drying it between times, I have succeeded in increasing its sensibility. For fixing the images, after having tried ammonia and several other reagents with very imperfect success, the first thing which gave me a successful result was the iodide of potassium, much diluted with water. If a photogenic picture is washed over with this liquid, an iodide of silver is formed which is absolutely unalterable by sunshine. The specimen of lace which I exhibited to the Royal Society, and which was made five years ago, was preserved in this manner. But my usual method of fixing is different from this. It consists in immersing the picture in a strong solution of common salt, and then wiping off the superfluous moisture and drying it."

Applications of Photogeny.—Talbot's first application of his process was to the copying of flowers and leaves selected from his herbarium. In those early days of the art, the vast saving of time and trouble effected seems to have struck the observers very forcibly. In the same memoir Talbot remarks : " It is so natural to associate the idea of *labor* with great complexity and elaborate detail of execution, that one is more struck at seeing the thousand florets of an *agrostis* depicted with all its capillary branchlets (and so accurately that none of all this multitude shall want its little bivalve calyx, requiring to be examined through a lens) than one is by the picture of the large and simple leaf of an oak or a chestnut. But in truth the difficulty is in both cases the same. The one of these takes no more time to execute than the other; for the object which would take the most skilfull artist days or weeks of labor to trace or to copy is effected by the boundless powers of natural chemistry in the space of a few seconds."

To give an idea of the degree of accuracy with which some

* *Philosophical Magazine*, 1839, p. 209.

objects can be imitated by this process, I need only mention
one instance. Upon one occasion, having made an image of a
piece of lace of an elaborate pattern, I showed it to some per-
sons at a distance of a few feet, with the inquiry, whether it
was a good representation ?: when the reply was, "that they
were not to be so easily deceived, for that it was evidently no
picture, but the piece of lace itself."

It is to be regretted that "photogenic drawing" seems to
have almost fallen into disuse. With our ordinary sensitized
paper, or with paper prepared in the way described by Talbot,
very beautiful copies of suitable natural objects—ferns for ex-
ample—can be obtained. The process forms a capital intro-
duction to photography, and is especially suitable for ladies
and children. The copies obtained can be used for many deco-
rative purposes.

The First Portraits Printed by Light.—In Talbot's first
communication (1839) he clearly recognizes the valuable fact
that the pictures obtained by his process are *negatives,* from
each of which any number of *positives* can be obtained by
printing. Thus he writes: "In copying engravings, etc., by
this method the lights and shadows are reversed, consequently
the effect is wholly altered. But if the picture so obtained is
first *preserved,*[*] so as to bear sunshine, it may be afterwards
itself employed as an object to be copied; and by means of
this second process the lights and shadows are brought back
to their original disposition." But the inventor did not
then think of employing photography as a means of por-
trait-taking, except indeed for "the making of outline por-
traits, or *silhouettes.* These are now often traced by the
hand from shadows projected by a candle. But the hand
is liable to err from the true outline, and a very small
deviation causes a notable diminution in the resemblance. I
believe this manual process cannot be compared with the truth
and fidelity with which the portrait is given by means of solar
light."

But the improvements patented by Talbot in 1841, with
others added by Cundell in 1844,[†] so improved the *Calotype*

[*] *i.e.,* fixed.
[†] *Philosophical Magazine* for May, 1844.

Process (as Talbot then styled his method) that it became applicable to portraiture, and the inventor granted licenses to several professionals to use it for likeness-taking. The first of these was Mr. Henry Collen, of London, of whose "beautiful Talbotype miniatures" a contemporary reviewer remarks * that, "touched up and improved, they show how much is yet to be accomplished by the application of artistic skill to the productions of the solar pencil."

Books Illustrated by Photographs.—Talbot believed strongly in the suitability of photography for book illustrations, and in 1844-46 he issued a series of twenty-four plates (positive prints from calotypes) under the title of the "Pencil of Nature." The subjects include the Boulevards of Paris, Bridge of Orleans, Lacock Abbey, etc. In only one picture are figures introduced. In all existing copies of this valuable book which we have examined, the photographs are more or less faded, yellow outlines only being visible, though a few of the photographs are still of a purplish hue in the central part. A description of the methods employed in the printing is given by Mr. Malone in the *Liverpool and Manchester Photographic Journal*, 1857, p. 270; and 1858, p. 23.

In 1846, Talbot published a similar book, entitled "Sun Pictures in Scotland," and a specimen of his work was given in the *Art Journal* for June 13th, 1846. The first scientific periodical which contained a photograph as an illustration was, we believe, the *Quarterly Journal of Microscopical Science* for April, 1853. Two Scotch photographers, Messrs. Hill and Adamson, prepared large collections of Talbotypes, about 1850, which were sold at prices of £40 and £50 each.

In later years, more especially about 1866-70, many books, some of them very expensive, were published, in which photographs of works of art, pictures, scenery, etc., formed the principal features; but a radical defect in most or all of these was the gradual fading and yellowing of the pictures, so that purchasers became very chary of paying from three to ten guineas for such unstable productions. During the last few years, however, since 1883, say, the introduction of such per-

manent processes as carbon and platinotype, together with the advance of the photo-mechanical methods, bid fair again to bring photography to the front, and to give it that leading place to which it is entitled as a mode of illustrating books.

It may be interesting to add here that the first public exhibition of photographs was held under the auspices of the Society of Arts, in their room in the Adelphi, London, on December 22d, 1852. This exhibition resulted in the formation of the Photographic Society of London, on January 30th, 1853, and this society has ever since held an annual exhibition of photographs in London.

Printing on Plain Salted Paper.—Fox-Talbot's method of printing upon ordinary white paper has come down almost unaltered to the present day. The standard size of the paper employed is 23½ by 17 inches, and it is nearly all made at the little towns of Rives in France, and Saxe in Germany. Thirty years ago the principal makers of photographic paper were Hollingworth and Sanford in England, and Canson in France, but for some reason or other the two towns above-named now enjoy a practical monopoly. The chief points to be attended to in making paper for use in photography are the avoidance of metallic particles—such as might come from buttons in the rags, etc., and of the hyposulphite of soda which is largely used by ordinary paper-makers in the process of whitening the paper, but which is very destructive to photographs.

The paper is "salted" by being floated for three minutes upon the following solution :

Water...500 parts.
Ammonium chloride 8 parts.
Sodium citrate. 10 parts.
Gelatine...................................... 1 part.

It is then dried and sensitized by being floated for the same length of time upon a solution of silver nitrate, fifty grains to the ounce ; when dry it is ready for use.

Printing on Albumenized Paper.—Plain salted paper is most useful where the photograph is to be afterwards colored, as it gives a dead surface which is easy to work upon ; but, unless special precautions are taken, the image has a gray and sunken-in appearance. To remedy this, a quantity of albumen

(white of egg) is now almost always mixed with the first or "salting" solution. This fills the pores of the paper and keeps the sensitive salt of silver (silver chloride) which is subsequently formed by floating the prepared paper upon silver solution, upon the surface ; its gloss is also considered to add to the appearance of the picture. The introduction of albumenized paper has been credited to Fox-Talbot, but the first description of it which I have been able to find in English is in the third edition of "Hunt's Manual of Photography" (preface dated December, 1852), where it is given as an extract from a book by the French investigator Le Gray. There is another account of the process, by H. Pollock, in the journal of the (London) Photographic Society for July, 1853.

Papers tinted pink, mauve, etc., were introduced in 1863, and enameled paper (to give greater brilliancy) about the same time.

Thomas Sutton patented (October, 1862) a plan of giving paper a preliminary coating of India rubber dissolved in benzole before albumenizing it. This completely prevented the solutions sinking into the paper and caused the prints to be more vigorous and brilliant. Such paper was manufactured for several years by Messrs. Ordish in London.

In 1866, A. Taylor used * a solution of bleached shellac in phosphate of soda to prepare the paper instead of albumen. Great permanence was claimed for this method.

In 1842, Dr. A. S. Taylor (and A. Smee and Mr. Collen, about the same time) used ammonio-nitrate of silver to sensitize plain salted paper with good results. Albumenized paper cannot be sensitized in this way, inasmuch as it is dissolved by the ammonio-nitrate.

Printing with the Juices of Flowers.—In 1842, Sir John Herschel devoted much time to experiments upon printing on paper soaked in the coloring matter extracted from the petals of many species of flowers. The petals were crushed in a mortar, a little alcohol added, and the pulp was then strained through a cloth. The liquid so obtained was then spread upon paper with a brush and dried in a dark place. Poppies, violets,

* *Photographic News*, June 15th, p. 280.

roses, etc., were tried with success; but the exposures required
to produce a visible impression were very long, extending over
weeks, or even months.*

"*Printing-out*" *on Gelatino-Chloride Paper.*—More than
twenty years ago Palmer and Smith showed † how paper
coated with an emulsion of gelatino-chloride of silver could be
used for coating paper for photographic printing.

In 1881, Dr. Eder and Capt. Abney published ‡ further de-
tails; while W. T. Wilkinson gave a number of practical de-
tails in the *British Journal of Photography* for the same
year.§

Aristotype Paper.—In 1886 the firm of Liesegang, of Dus-
seldorf, in Germany, prepared a paper coated with gelatino
citro-chloride of silver, which, under the name of "Aristo," or
aristotype paper, has found favor, especially for printing from
weak negatives. The picture is "printed-out," as upon ordi-
nary albumenized paper, but it only requires about one-third
of the time; it must then be toned and fixed. A similar
paper is manufactured by Obernetter.∥

Ready-sensitized Paper.—The albumenizing of paper is so
troublesome an operation that it has been left, almost univer-
sally, to the manufacturer. But it is the custom with profes-
sional photographers and with many others to sensitize for
themselves the already salted and albumenized paper by float-
ing it upon a bath of silver nitrate. Unfortunately, it is the
case that paper sensitized in this way loses its color rapidly.
It ought, in fact, to be used as soon as it is dry. The con-
venience of a paper which could be purchased *ready sensitized*
and which would *keep* for a reasonable period, was doubtless
recognized at an early date; and such an article came into use
commercially in 1869, and is now largely used; yet, strange to

* See Herschel "On the Action of the Solar Spectrum on Vegetable
Colors"; Philosophical Transactions, 1842, part ii., p. 181.

† *Photographic News*, 1866, p. 24, 36.

‡ Ibid, p. 400.

§ Pp., 140, 168.

∥ This well-known Munich photographer has died since this sentence
was written, but the paper will doubtless be continued to be issued under
his name.

say, the exact method of preparation has been successfully kept a " trade secret."

Mr. J. C. Hopkins, in the *Photographic News* for 1873, stated that ordinary sensitized paper keeps well if placed when nearly dry between sheets of blotting-paper which have been soaked in carbonate of soda solution (thirty grains to the ounce of water), and then dried. Pads of carbonated blotting-paper placed behind the negative in the printing-frame, also answer well.

Captain Abney washes the sensitized paper (to remove the free silver nitrate) and then dips it into a weak solution of either potassium nitrite or potassium sulphite.

Mr. W. Bedford sensitizes the paper on a neutral bath, and then floats the face upon a bath containing thirty grains each of citric acid and of silver nitrate to the ounce of water.

Another method is to float the *back* of the paper, after sensitizing, upon a weak solution of citric acid. The addition of this substance to the printing bath was recommended in 1863 * by Colonel Stuart Wortley. It is believed that much of the ready-sensitized paper made at the present day is sensitized upon a nitrate of silver bath to which citric acid and a little gum has been added. M. Baden, of Albona, found that by washing sensitized paper (to remove the free nitrate of silver) the paper would, keep for a long time; but, before using, it *must be fumed with ammonia.* This method was introduced into England in 1870, by Colonel Stuart Wortley. †

Ammonia fuming has been used with great success in America (where it was introduced in 1863), but has not met with much favor in England, although its effects are undeniably good, and " old " samples of paper may often be made available for use by simply fuming them.

Combination Printing.—It is a common practice with artists to "improve" any landscape which they may be engaged in painting by the omittal of such portions as would tend to mar the effect of the finished picture, replacing them by objects sketched in another locality. Figures, too, are introduced

* *Photographic Journal.* February 16th, 1863.
† *British Journal of Photography*, p. 337.

where and as required. Such a power of selection is generally considered to be beyond the means of the photographer; but that it has been possible to produce a single print or finished picture by combining two or more negatives has been known and successfully practiced for more than thirty years.

At an exhibition held in connection with the meeting of the British Association in Glasgow, in 1855, Messrs. Berwick and Annan, of that city, exhibited a picture "printed from two different negatives"—a figure introduced into a landscape. The process was exactly that subsequently used by Mr. H. P. Robinson, which we have described further on.

On April 5th, 1858, O. Sarony patented a means of "producing a positive portrait by means of two or more negatives." The first part of the "patent" is practically Berwick and Annan's method, but he adds, "these improvements may also be effected by taking up the different portions of the collodion film from the glass of one or more negatives and laying them down on a glass or in the printing-frame in their proper relative positions, and then printing from them without marks.

This reminds us of the plan adopted by many in 1885 (when paper negatives came into general use), of cutting out the parts required from each negative with a sharp pair of scissors, and fitting them accurately together on a sheet of glass.

The first man to attract general attention to combination printing was Oscar G. Rejlander (born 1803, died 1875), a Swedish artist, who practiced photography at Wolverhampton, and who in 1857 sent a very large photograph called "The Two Ways of Life" to the famous Manchester Exhibition of that year. Thirty negatives were employed in printing this photograph,* each being laid in turn upon the sensitized paper and exposed to sunlight, while the rest of the paper was covered over with black velvet. As an example of ingenuity and power to overcome difficulties, this picture has never been surpassed.

In the next year, 1858, Mr. H. P. Robinson produced his famous combination picture (printed from five negatives), en-

* "On Photographic Composition; with a Description of 'The Two Ways of Life,'" by O. G. Rejlander. *Photographic Journal* for 1858, p. 191.

titled, " Fading Away," a consumptive girl surrounded by griev-
ing friends, which was exhibited in January, 1859, before the
London Photographic Society.* It attracted great attention,
and much difference of opinion was excited as to the pro-
priety of photography being employed to delineate such a
subject. But all opposition was stopped by the splendid series
of photographs with which Mr. Robinson followed up his first
success, including " Bringing Home the May," 1863, (size
40 by 15 inches, printed from nine negatives), " Wayside Gos-
sip," "A Merry Tale," and a score of others, the result of the
artist's noble resolve " to do something, at least one picture
every year, for the love of art and of photography." Mr. Rob-
inson's method may be called the " stopping-out " plan. As
many negatives as are required are taken, and then from each
is stopped out in some way or other—as by painting over with
black varnish, or gumming on paper—all but the part re-
quired. The sensitive paper is then printed in turn under
each negative.

Printing-in Clouds.—This is merely a variety of combina-
tion printing. In the early days of photography, about 1855
say, a perfectly white clear sky was much admired. In the
very first number of the *Photographic Journal* (March,
1853), Sir W. J. Newton suggests the addition of clouds by
the use on the skies of dense negatives of cyanide of potas-
sium ; or of India ink upon thin ones. About 1862 the de-
sirability of adding clouds to landscape prints was generally
recognized, and at first this was done by painting or dabbing
upon the back of the negative. Then separate cloud-negatives
were taken, and these " natural clouds" printed-in by meth-
ods which are well explained by V. Blanchard in the *Photo-
graphic News* for September 4th, 1863.

Vignetting.—This mode of shading-off the light so as to
cast a halo round the picture is described by Mr. Latimer
Clark in the *Photographic Journal* for December, 1853 He
placed a sheet of some opaque substance having a hole cut in

* Mr. Robinson's first description of his method is contained in a paper
printed in the *Photographic Journal* for April 16th, 1860 ; but his method
is fully described in the book on " Silver Printing" (chap. xiv.), which he
wrote in conjunction with Capt. Abney.

the center, in front of the negative and about half-an-inch above it. The printing frames so fitted were placed on a light stage which was made to revolve by means of a bottle-jack. Vignetting came into extended use in 1857–58. Mr. Forrest, of Liverpool, was the inventor of the stained and ground vignetting-glasses now so commonly used.

History of Toning Processes.—" Toning," as photographers call it, is practically gilding the image formed by light, either by a thin deposit of gold upon the silver of which the image is composed, or by the replacement of part or the whole of the silver by gold. In 1841 * the French scientist, Fizeau, toned daguerreotypes by applying to the heated surface of the silver plate a mixture of hyposulphite of soda and chloride of gold.

The early paper prints of Talbot were of a foxy-red or bister tint, due to the color of the deposited silver in a finely divided state, modified by the " size" with which the paper was impregnated. By using continuously the same fixing bath (adding crystals of hypo occasionally to keep up its strength), or by placing such prints in an " old hypo bath," *i. e.*, one already impregnated with chloride of silver and which had been allowed to stand for a week or so, or until a black deposit was seen to form, the prints were changed in color from red to brown or black. This process was largely used between 1848 and 1855 ; it was really "sulphur toning," the black color being due to the formation of sulphide of silver. A sulphur-etted organic salt of silver was, however, also formed, and under atmospheric influences this speedily altered, reacting in addition upon the other substances present, At this period, moreover, the necessity for a thorough removal of the hyposulphite of soda used in fixing was not generally recognized, and its presence contributed to a rapid fading of the picture. It is doubtful whether a single photograph taken before 1855 could be produced to-day which has not undergone serious, and for the most part fatal deterioration.

Very valuable information on these points is contained in a

* Communicated to the Academie des Sciences on May 15th and 24th, 1841.

report of a committee of the London Photographic Society,* appointed in May, 1855, His Royal Highness, the Prince Consort (who always took a lively interest in photography), contributing £50 towards the expenses of the inquiry.

The proved advantages of the addition of chloride of gold to the hypo solution for toning daguerreotypes naturally led to its trial for the same purpose for toning paper prints. In Gustave Le Gray's book (published in France in 1849), he writes: " I obtain also fine velvet-like tints by putting the photograph (when taken out of the hyposulphite of soda), upon a bath of salt of gold, using fifteen grains of the chloride of gold to one pint and a half of distilled water." In this method we see that toning followed fixing; and such was for a long time a general custom, being recommended, for instance, by Hockin, in 1860, in a book † which had a very large circulation. A disadvantage of Le Gray's method was that the prints were very much weakened by the toning process, necessitating a great amount of over-printing to commence with. The gold solution was always acid.

In 1855, Thomas Sutton recommended ‡ the use of an acid bath of *sel d'or* for toning. *Sel d'or* is a compound of chloride of gold and hyposulphite of soda, formed by mixing concentrated solutions of the two salts, and then precipitating the double salt by the addition of alcohol. The print was washed before toning, and fixed afterwards. This process became popular; but it was ultimately abandoned because—as there was no means of knowing how much gold remained in the bath at any given time—it degenerated in the hands of most photographers into mere sulphur toning, the bath being kept in use long after the gold was exhausted.

The classical investigations of Hardwich, in England,§ commenced in 1854, and of Davanne and Girard, in France (1855 and following years), laid down the lines upon which the print

* *Photographic Journal*, vol. ii., p. 251 ; see also " Reports of Juries," Exhibition of 1862.

† " Practical Hints on Photography," by J. B. Hockin.

‡ *Photographic Journal*, vol. ii., p. 133.

§ Ibid, vol. iii., pp. 35, 268 ; vol. iii., etc.

ought to be treated after its removal from the printing-frame; and minor investigators filled in the details.

In 1855, Mr. Waterhouse, of Halifax, the inventor of the removable diaphragms which bear his name, introduced a most valuable improvement in toning processes by the use of an alkaline (or, at all events, strictly non-acid) solution of the chloride of gold. The alkali used by Waterhouse was carbonate of potash, and he " added more or less of it according to the tint desired." This process was first published in 1856 in the third edition of Hardwich's " Photographic Chemistry," and was subsequently recommended by Mr. Hardwich in a paper read before the London Photographic Society.* Soon the changes were rung on all the alkalies; Hardwich (in 1856) substituted carbonate of soda for the potash " as being a salt more easily obtainable"; within the next year or two the Abbé Laborde (in France) and Hannaford † (in England) used acetate of soda; and in 1858 Maxwell-Lyte ‡ recommended the phosphate of soda, his formula being

> "Terchloride of gold..................10 grains.
> Phosphate of soda (pure)........................ 3 drams.
> Distilled Water................................. 1 pint."

At that time the toning process was commonly called " coloring"—thus Maxwell-Lyte's paper is entitled, " A Process for Coloring Positives;" in a postscript to it he adds, " the phosphate of soda may be replaced by common borax." From this time (1858–59) the principal toning processes may be said to have remained practically unchanged to the present day.

History of Fixing Processes for Prints.—The only thing deplored by Wedgwood and Davy in 1802 was their inability to discover any satisfactory solvent for the salts of silver—the muriate (or, as we should now call it, the chloride) and the nitrate—which they employed.

In 1819 Sir John Herschel pointed out § the ready solubili-

* *Photographic Journal*, vol. v., p. 95.
† Ibid, vol. vi. for 1859, p. 83.
‡ Ibid, vol. v., p. 112.
§ *Edinburgh Philosophical Journal.*

ty of silver salts in the alkaline hyposulphites. From this time the problem of photography was solved; but, unfortunately, Niepce, Daguerre, and Talbot seem to have known nothing of the work already done by Davy and by Herschel.

In 1839 Daguerre fixed his iodized silver plates by washing them either with ammonia or with a strong solution of common salt.

At the same time Fox-Talbot used common salt, and also solutions of bromide of potassium and iodide of potassium.

Immediately Herschel heard of Daguerre's and of Talbot's successes in photography (in January, 1839), he remembered the substance whose solvent powers for silver salts he had announced in 1819 (hyposulphite of soda), and the directions which he gives for its use in a valuable paper, read before the Royal Society on February 20, 1840, have ever since formed the foundation of our ordinary method of fixing photographs on paper. Herschel writes, after washing in pure water, the paper must be dried, " and then brushed over very quickly with a flat camel's-hair brush, dipped in a saturated solution of the hyposulphite, first on the face, then on the back. This having remained on it till the paper is completely penetrated with it, it must be washed off with repeated and copious effusions of water, aided by a soft sponge, with a dabbing motion, often turning the picture until the liquid comes off without the slightest *sweetness*. The photograph is then fixed, and may be dried and put by; but to make it quite secure it is best to repeat the process, and if the paper be thick, even a third time. The hyposulphite of soda and silver being liable to spontaneous decomposition, it is necessary to be very careful in washing away the very last traces of this salt."

It would have been well if the early photographers—under which phrase we include the workers before 1855—had paid more attention to Herschel's remarks; then we should have had more of their work remaining. Indeed, the men of to-day might remember the advice as to sponging and dabbing—Captain Abney strongly recommends this plan—for by applying pressure in this way to the prints a photograph may be more thoroughly freed from hypo in two or three hours than by days of mere soaking; the result too, being a more brilliant print.

In the face of Herschel's work, it is difficult to understand how Fox-Talbot could have included as part of a patent for " Improvements in the Calotype Process," which he took out in 1843, a claim to "give increased whiteness to calotype and other photographic pictures, and at the same time make them more permanent, by plunging them into a hot solution of hyposulphite of soda (or any other soluble hyposulphite) after which they are removed, washed, and dried."

In the first edition of his " Manual of Photography," published in 1841, Robert Hunt remarks :

(*a*) " That prints upon nitrate of silver may be fixed by washing with distilled water only.

(*b*) " That prints upon chloride of silver are ' half-fixed ' by thorough washing with pure water.

(*c*) " I have in my possession some pictures which have been fixed with a strong *brine*, and subsequently washed with warm water. They have become slightly blue in the white portions, but otherwise they are very permanent.

(*d*) " Chloride of silver being soluble in solution of ammonia and some of its salts, they have been recommended for fixing agents. The ammonia, however, attacks the (silver) oxide, which forms the darkened part in some preparations, so rapidly, that there is great risk of its destroying the picture, or at least of its impairing it considerably. It matters not whether the liquid ammonia or its carbonate be used, but it must be a very diluted solution.

(Quite recently ammonia has again been brought forward as a fixing agent by Mr. R. H. Bow of Edinburgh.*)

(*e*) " The ferrocyanate of potash, or, as it is more commonly called, the prussiate of potash, converts the chloride into a cyanide of silver, which is not susceptible of change by light; consequently this cheap salt has been employed as a fixing agent; but, most unfortunately, photographs which have been subjected to this preparation are slowly, but surely obliterated in the dark.

(*f*) " The iodide of silver, which is readily formed by washing the photograph with the solution of the iodide of potassium,

* *Photographic News*, 1887, p. 234.

is scarcely sensitive to light. It tinges the white lights of the picture of a pale yellow—a color which is extremely active in absórbing the chemical rays of light, and is therefore quite inapplicable where any copies of the original photograph are required.

(g) "Of all the fixing agents, the hyposulphite of soda is decidedly the best."

These remarks on fixing agents are repeated in the later editions of Hunt's popular manual. They are taken mainly from Herschel's paper of 1840 referred to further on.

About 1850, Reuben Phillips used electricity to accelerate the fixing process. He employed "electrodes the size of the photograph to be fixed, and placing upon the under one a flannel wetted with the fixing agent, he placed the print, wetted with the same solution upon it, and laid another wetted flannel upon the print, covering the whole with the other electrode. Connecting the electrodes with a galvanic battery, the metallic salt is rapidly removed to one pole, and thus the fixing process rendered comparatively short and easy."

J. H. Croucher in a book published in 1845, advises * "to fix the picture, soak it for two or three minutes, or longer if strongly developed, in a solution of half an ounce of hyposulphite of soda to a pint of water, turning it occasionally ; and then soak it in water for twelve to twenty-four hours."

In Le Gray's book, edition of 1849, he gives (in addition to the hypo bath) a fixing solution of bromide of potassium, 360 grains to $1\frac{3}{4}$ pints of water; its advantage being the avoidance of the use of hypo when traveling, the latter salt being even then recognised as likely to spoil everything photographic with which it came into contact.

Other fixing agents suggested by Herschel in 1840 were hydriodate of potash and chromate of silver.

From the remarks made in the paragraphs on toning processes, it will be seen that the operations of toning and fixing were most commonly performed in one and the same bath—

* See also paper by R. Hunt "On the Use of the Hydriodic Salts as Photographic Agents," *Edinburgh Philosophical Magazine*, September and October, 1840.

first of old hypo alone, and then of hypo, plus chloride of gold—from 1839 down to 1858; the advantage of separating the one process from the other being first authoritatively shown in Mr. Hardwich's paper communicated to the London Photographic Society in December, 1858. From that date down to the present day hyposulphite of soda has been, we may say, universally used for fixing positive prints on paper, the best proportions being three ounces of the salt to each pint of water. The hypo should be kept alkaline by the addition of a little carbonate of ammonia.

"Hyposulphite of soda" was first prepared by Chaussier in 1799, and was first studied by Vauquelin. In 1869, Schutzenberger showed that the so-called "hyposulphurous acid" was really *thiosulphurous* acid,* from which it resulted that the salts previously called "hyposulphites" were really *thiosulphates*. The correct chemical name of $Na_2S_2O_3$ is therefore sodium thio-sulphate, but its old name of "hypo" will probably stick to it as long as the present generation of photographers exists.

Magic Photographs.—In Herschel's excellent paper, published in 1840,† he writes: "By far the most remarkable fixing process with which I am acquainted, however, consists in washing over the picture with a weak solution of corrosive sublimate (mercury bichloride), and then laying it for a few moments in water. This at once and completely *obliterates* the picture, reducing it to the state of perfectly white paper, on which the nicest examination (if the process be perfectly executed) can detect no trace, and in which it may be used for any other purpose, as drawing, writing, etc., being completely insensible to light."

"Nevertheless, the picture, though invisible, is only dormant, and may be instantly revived in all its force by merely brushing it over with a solution of neutral hyposulphite, after which, however, it remains as insensible as before to the action of

* *Comptes Rendus*, vol. lxix., p. 196.

† On the Chemical Action of the Solar Spectrum ; on Preparations of Silver and other Substances, both Metallic and Non-metallic ; and on some Photographic Processes : " Philosophical Transactions." 1840, part i.

light. And thus it may be successively obliterated and revived as often as we please. It hardly requires mention that the property in question furnishes a means of painting in mezzotint (*i.e.* of commencing on black paper and working in the lights), as also a mode of secret writing, and a variety of similar applications."

In 1866 these "magic photographs" obtained widespread popularity. They were sold everywhere at a cheap rate. The improvement which brought them into notice consisted in selling with each photograph a piece of blotting paper which had been saturated with hyposulphite of soda and then dried. It was only necessary to dip this into plain water and lay it upon the "magic photograph" to cause the picture to appear.

Cyanide of potassium was used by M. A. Gaudin in 1853,[*] for fixing collodion positives on glass, and for such work it has ever since been preferred to hyposulphite of soda. Cyanide, however, is not fitted for fixing paper prints on chloride of silver, since it attacks the image. In extremely dilute solution (four drops saturated solution to the pint of water) it has, however, been found useful for reducing overprinted proofs. Vernier, in 1860, used it for this purpose. One great drawback to the use of this substance is its terribly poisonous nature.

Sulphite of soda was shown in 1885,[†] by Captain Abney, to be an excellent fixing agent, though about twelve times more expensive than hypo. It should be used in the proportions of four ounces to the pint of water.

Sulpho-cyanide of Ammonia was proposed as a fixing agent by M. Meynier in 1863.[‡] It gives a yellow hue to albumenized paper, but answers well for proofs on plain salted paper. A compound fixing and toning bath of this salt, plus chloride of gold, is said to answer admirably for the "Aristotype" paper lately introduced.

[*] *La Lumière*, April 23d, 30th.
[†] *Photographic News*, pp. 339, 354, 370.
[‡] *Bulletin de la Société Francaise.*

CHAPTER XII.

HISTORY OF PHOTOGRAPHIC PRINTING PROCESSES.—Continued.

Printing by Development. (1) *With Iodide of Silver.*—In dull weather and in winter it is sometimes found impossible to get a single print for days together by the "printing-out" process upon our ordinary printing paper, which contains chloride of silver in albumen. The advantage of employing a method of development to produce positive prints from negatives, as well as the negatives themselves, was recognized at an early date, for the necessary time of exposure to light was thereby reduced from hours it might be to seconds ; moreover, the prints so obtained are undoubtedly more permanent.

In the Report * of the Jurors of the Exhibition of 1851, they state that Blanquart Evrard (France) has proved "that from one good original negative (Talbotype), any number of positive copies may be taken to the extent, indeed, of two or three hundred copies in a rainy day." The following graphic description of how 250 prints were produced from one negative with one pressure frame in one hour and fifty minutes, is by Thomas Sutton,† who was himself for some time a partner with Blanquart Evrard about the year 1857 : " The single pressure frame employed is contrived to run in and out of a window on a platform provided with rails. The window has a dark shutter which works up and down like a guillotine. Each print was exposed separately for a few seconds. The time occupied in exposing the 250 was about an hour and a half. The operation was conducted by a girl with a metronome at her side which ticks seconds. When a certain number had been exposed they were taken to the developing room. Here three or four girls were employed in developing the pictures.

* Page 277.
† See *Photographic Notes*, 1856, p. 63.

They used large glass dishes and each girl developed twenty or thirty at a time. The development of each print occupied about twenty minutes. Of the 250 prints produced on that occasion, 13 were rejected, and the remainder were published and sold."

"The girls employed divide their time between photography, and agricultural and other pursuits. When a sufficient quantity has been ordered a day is fixed and it is done. This is the way in which we print by the method of development. During the last five years at M. Blanquart Evrard's establish ment at Lille, a staff of country girls have produced more pre- sentable prints by the method of development than all the rest of Europe combined by other printing processes."

This development-printing process consisted in sensitizing iodized paper upon a solution of silver nitrate (thereby pro- ducing iodide of silver with an excess of nitrate of silver upon the paper), and then, after exposure beneath the negative, brushing over it a solution of gallic acid. This method was, therefore, practically identical with the calotype process. The defects were the "cold tone" of the prints, with a "lack of purity in the whites." No toning bath was employed. The *Photographic Album*, issued in monthly parts (price 6 shil- lings), by Sutton and Blanquart Evrard, in 1856, contained four developed prints in each part, and for some years Sutton challenged anyone to produce one of these prints which, hav- ing had fair treatment, had faded.

(2) *With Bromide of Silver.*—In 1854, Sir W. J. Newton described * a method almost identical with that given above, except that silver bromide was formed on the paper instead of silver iodide. The time of exposure required was from half a minute to three minutes, according to the (sun) light.

Development-Printing on Gelatino-Bromide Paper.—The first notice of the now very popular and largely used gelatino- bromide paper is contained in the "British Journal Almanac" for 1874, where Peter Mawdsley (of the Liverpool Dry-Plate Co.) advertises gelatino-bromide plates (price 4s. per dozen, quarters), and adds: "in addition to the plates, we can supply

sensitive paper at from 20 to 25 per cent. less cost, including postage."

"For those who object to the weight and fragile nature of glass as a support for the sensitive film, the paper possesses many advantages; in fact, there is but *one* drawback to its use—the slight texture, which, however, by skill and care in printing, may be reduced to a minimum. It may also be used for positive proofs by contact and development-printing, an exposure of a few seconds to gas or other artificial light being sufficient. It will be found invaluable for enlargements."

In the body of the same book a capital article, by P. Mawdsley, also appears (page 129) on the "Development of Gelatino-Bromide Plates and Paper," in which he recommends our ordinary pyro-ammonia developer, restrained with bromide.

On July 22d, 1879, J. W. Swan patented in England "a method of printing by development on surfaces coated with bromide emulsion."

He added "small quantities of alum and carbolic acid to make the emulsion less soluble," or else submitted the coated surface to the action of steam for the same purpose. The printing was done "either in the camera or by contact (artificial light preferred), developed with ferrous oxalate," and fixed in the usual way with hypo.

In 1880 Messrs. W. T. Morgan & Co.,* of Greenwich, near London, commenced the manufacture on a large scale of paper coated with gelatino-bromide emulsion. In a pamphlet written for the firm by John Burgess, and published in July, 1880, it is stated that such paper had been made by them since 1874.

In 1881 T. C. Roche took out a similar patent in America.

In June, 1882, Messrs. Morgan & Kidd patented a method of coating or enameling paper with an impervious and insoluble layer of gelatine containing alum; this layer prevented the film of emulsion subsequently applied from sinking into the paper, and thus rendered it available for the production of brilliant pictures from small negatives by contact printing.

Messrs. Hutinet and Stebbing in 1883 made a tour of Great

* Now Morgan & Kidd, of Richmond, Surrey.

Britain, demonstrating in the principal towns the easy method of enlarging with the lantern upon gelatino-bromide paper.

While speaking of enlarging we may remark that an article, describing a method of enlarging by daylight, devised by Heilmann, appeared in the *Athenæum* for July 9th, 1853.

The Eastman Co., of Rochester, N. Y., exhibited their photographic paper and appliances at the Inventions Exhibition, South Kensington, in 1885, and a notice of their work appeared in the *Times* for August 11th of that year. The paper is given a preliminary coating of gelatine, is then calendered, and finally receives a double coating of gelatino-bromide emulsion. The paper used for positive printing requires an exposure, when in contact with the negative, of from three to twenty seconds. It is developed with ferrous oxalate, and requires no toning.

History of Development-Printing on Gelatino-Chloride of Silver Paper.—The *Times* newspaper for November 24th, 1884, contains a description of a new printing paper issued by Marion & Co., of Soho Square, London, and called the " Alpha," of which, although the precise formula has not been published, we know that it consists of silver chloride, together with a little silver bromide, contained in gelatine. The special advantages of this paper are cheapness and the warm and varied tones which can be obtained ; it generally requires toning, however. This paper has been successfully used in connection with an automatic printing machine invented in 1885, by John Urie, of Glasgow, with which 200 prints per hour can be obtained.

A very similar machine was invented in the United States many years ago by Fontayne.

The Alpha paper is exposed beneath a negative for from ten seconds to two minutes—according to the density of the negative—and then developed with ferrous oxalate.

A full and valuable description of the methods of making gelatino-chloride emulsion and spreading the same upon paper, opals and glass for positive printing, is contained in a long series of papers contributed by Messrs. Ashman and Offord to the *Photographic News* for 1885 and 1886.

History of the Carbon Printing Process.—When the early

photographers found their silver prints fade one by one, despair for a while took possession of their hearts; but they speedily rallied and began to look around for some permanent material in which to imprint their pictures. In 1856, the Duc de Luynes placed in the hands of the Photographic Society of France the sum of 10,000 francs, to be offered for the invention of a *permanent* photographic printing process; and in announcing this handsome donation, the then president of the society, M. Regnault, the famous chemist, directed the attention of inventors to *carbon* in the following words: * "Of all the substances with which chemistry has made us acquainted, the most permanent, and the one which best resists all chemical reagents in the temperature of our atmosphere is carbon. The present condition of ancient manuscripts shows us that carbon, in the form of lampblack on the paper, remains unchanged for centuries. If, therefore, it were possible to form photographic pictures in carbon, we should then have the same guarantee for their permanency that we now have for our printed books; and that is the best which we can hope or wish for."

Since carbon is unalterable by light, the next step was to find some substance *upon* which light could act, and *in* which finely divided carbon might be contained.

Such a substance was to hand in a mixture of bichromate of potash and gelatine, which, soluble enough if kept in the dark, becomes insoluble when exposed to light.

Mungo Ponton, in 1839, announced to the Royal Society of Scottish Artists that paper soaked in a solution of bichromate of potash and dried, is changed in color from yellow to brown by exposure to sunlight. He obtained copies of drawings in this way, and fixed them by simply washing them in water, which dissolved out the unaltered bichromate.

In 1840, Becquerel announced that if the paper was first sized with iodide of starch, it was more sensitive. Robert Hunt's "chromatype" process, published in 1843, varies only from Ponton's in the addition of sulphate of copper to the bichromate.

* *Bulletin de la Société Francaise de Photographie*, vol. ii., p. 215.

Joseph Dixon, of Massachusetts, copied bank-notes in 1841 by mixing gum arabic with bichromate of potash upon a lithographic stone, exposing to light through a bank-note, then washing away the unaltered portion of the gum, and, lastly, inking the stone and taking prints in the usual way. Dixon's method, however, was not published till 1854, when it appeared in the *Scientific American*.

The first "idea" of the chain of circumstances which has resulted in the carbon printing process of to-day is contained in a patent taken out by A. L. Poitevin on December 13th, 1855, in which he describes the effect of light upon a layer of "chromatized" gelatine, adding "a design is produced in color by mixing a suitable color with the above-mentioned organic mixture, and when the photograph is impressed, washing away those portions of the mixture which have not been acted upon by the light." The "suitable color" might, of course, be printer's ink, lampblack, or any other form of finely divided carbon.

On December 12th, 1857, Testud de Beauregard patented a further advance in the method of "producing photographic proofs or pictures by means of carbon or other coloring matter."

His favorite method, which we should consider all but impracticable, was to rub the pigment upon a surface of bichromatized gelatine; but he adds, "or the paper (to be colored) may be immersed in a bath of India ink or other pigment ground up very fine with water and mixed with bichromatized gelatine." The paper, having been prepared in the dark, is exposed beneath the negative to the action of light, after which it is washed in hot water. This "dissolves the gelatine which has been acted upon by the light, but does not dissolve that which has been rendered insoluble by the action of the light, and which insoluble gelatine retains the pigment, and thus produces the image."

Beauregard's statement contains a clear outline of the principle of the carbon process, but John Pouncy, of Dorchester, England, has always claimed to be the first to actually produce successful carbon prints. The specification of his patent is dated April 10th, 1858; but a fuller description of his method

is contained in Sutton's *Photographic Notes* for January 1st, 1859.

Pouncy exhibited his specimens at a meeting of the London Photographic Society, December 7th, 1858, from which body, however, he received little but depreciation and criticism. Pouncy's method consisted in brushing over and into paper a mixture of bichromatized gum and vegetable carbon; the paper was then dried, exposed beneath a negative, and finally the picture was brought out or made visible by washing in water.

By all these methods *half-tones* were wanting. The Abbé Laborde showed * the reason of this in 1858, saying : " In the sensitive film, however thin it may be, two distinct surfaces must be recognized, an outer, and an inner which is in contact with the paper. The action of light commences on the outer surface. In the washing, therefore, the half-tones lose their hold on the paper and are washed away." This was, in fact, the same defect which we have seen in connection with the bitumen process of the elder Niepce.

In the same year (1858) J. C. Burnett gave a partial remedy for this defect by exposing through the *back* of the coated paper; placing, in fact, the *uncoated side* next to the negative. But in 1860, Fargier, in France, showed that the best way was to coat the exposed film with collodion, then *transfer* it bodily to glass, and wash away the unacted-on gelatine from the thus exposed back surface of the film. A similar process had been previously used by Poitevin, to whom the greater portion of the Duc de Luynes' prize was ultimately awarded in 1867.

Improvements quickly followed; in 1864 J. W. Swan patented " carbon-tissue," which is simply paper coated with a mixture of gelatine, sugar, and coloring matter, "resembling black oil-cloth in appearance," and which can be sensitized at any time by floating it on a solution of potassium bichromate. The final touches necessary for success were given by J. R. Johnson in 1869, and by the "flexible support" patented by J. R. Sawyer in 1874.

At present the carbon process is largely worked by the

* *Bulletin de la Société Francaise de Photographie,* vol. ii., p 216.

"Autotype Company," of Oxford Street, London, whose "autotypes" (carbon prints), made of any size up to twelve square feet, are alike beautiful and permanent.

The "tissue" is usually purchased from the company, but if "ready-sensitized," it must not be kept long, as it rapidly deteriorates. The exposure is a somewhat "blind process," as it effects no visible change on the black surface of the tissue, but it is rendered easy by the aid of an actinometer. The tissue is then soaked in cold water, squeegeed on to a piece of "Sawyer's flexible support," and washed with warm water till the paper backing and soluble gelatine are removed. The picture is finally retransferred to its permanent support, usually white paper coated with insoluble gelatine.

From this brief description it will be seen that the carbon process is scarcely suitable for photographers who "don't like much fuss or trouble, you know." It is, however, admirably fitted for commercial work and for the production of enlargements.

History of Printing with Salts of Uranium— Wothlytype. —Gehlen, in 1804, noted that uranium chloride is affected by light.

But it was reserved for J. C. Burnett, in 1857–58,* and for Niepce de St. Victor, 1858–59,† to invent a practical printing process with this metal by floating paper upon a solution (1 to 30) of uranium nitrate, exposing beneath a negative until a faint image was visible, and then developing by floating upon silver nitrate solution (40 grains to the ounce) or upon chloride of gold (9 grains to the ounce of water). Light changes uranic into uranous nitrate, and the latter salt is able to reduce gold and silver to the metallic state from their solutions.

In 1864 Herr Wothly, of Aix-la-Chapelle, patented a printing process in which nitrate of uranium and nitrate of silver were contained in collodion, with which paper was coated. Beautiful prints were produced by the inventor, and a company, with Col. Stuart Wortley at its head, purchased the English patent; commercially, however, it proved a failure.

* *Photographic Notes*, 1857, pp. 97, 160 ; and *Photographic Journal*, 1859, p. 317.

† English patent, Feb. 27th, 1858.

History of Printing with Salts of Iron, Cyanotype, or the
"Blue Process."—Several chemists, from Bestuscheff, in 1725
downwards, noticed the action of light upon various compounds
containing iron, but Sir John Herschel in 1840 and 1842 [*]
was the first to use the salts of that metal for photographic
processes. Of the three methods which he devised, and which
he named respectively, *chrysotype, aurotype,* and *cyanotype,*
only the last-named has proved of practical value. Known as
the "blue process" (because the picture is produced in white
lines upon a blue ground), it is largely employed by engineers
and others for copying plans, etc. Paper is coated with a mix-
ture of ammonio-citrate of iron and potassium ferri-cyanide,
the action of light upon this mixture being to change it into
insoluble Prussian blue. The paper is dried, exposed beneath
the negative, and cleared by simply washing it in water.

History of Printing with Collodio-Chloride of Silver.—
In a preceding chapter we remarked that Marc Antony
Gaudin, of Paris, had suggested the preparation of a "photo-
gene" or liquid containing a haloid salt of silver with which
paper or plates might be coated; in 1861 he prepared such a
sensitive liquid with the iodide and the chloride of silver, but
achieved no practical success.

At the close of 1864, G. Wharton Simpson (then editor of
the *Photographic News*), announced [†] his discovery of a
printing process in which chloride of silver contained in col-
lodion was employed, and in March, 1865, he read a de-
scription of the process to the London Photographic Society.
Very beautiful results were obtained, especially upon opal
glass, but the collodio-chloride paper, though prepared com-
mercially in Germany, never got a fair footing in Great
Britain. From this remark, however, we must except Mr.
George Bruce, of Dunse, in the south of Scotland, who for
twenty years or more has sent out all, or the greater part of
his work, printed upon collodio-chloride paper; and with ex-
cellent results so far as beauty of appearance and perma-
nency are concerned.

[*] See the *Philosophical Transactions* for those years.
[†] "Photographic Year Book for 1865," p. 63.

Leptographic paper was a variety of collodio-chloride paper introduced on the Continent in 1866.

Willis's Aniline Process.—In November, 1864, W. Willis patented a process for reproducing plans, drawings, tracings, etc., without taking a negative. Paper prepared with an acid bichromate was exposed beneath the plan to be copied; it was subsequently developed by aniline vapor and fixed by washing in weak acid and in water.* The operation is cheap, and the result said to be permanent. The method, however, never came into general use.

Platinotype or Printing with Salts of Platinum.—Metallic platinum, which, like several other metals, is perfectly black when in the state of a fine powder, is one of the most stable substances known. It is not affected in the slightest degree by air, by moisture, or by acids; and hence any photograph composed of it may be reasonably said, so far as the platinum is concerned, to be absolutely permanent.

The fact that certain salts of platinum are sensitive to light was noted by Sir John Herschel in 1832,† and by Hunt in 1844. When organic substances are present, the light exercises a reducing influence, changing platinic salts into platinous, and the latter into metallic platinum. An organic salt of iron—ferrous oxalate—acts especially well in assisting this reduction.

In 1856, Caranza published ‡ a method for toning silver prints with an acid solution of platinum chloride; this gives black tones, while an alkaline solution gives brown ones. Eder and Toth (1875) showed that collodion negatives and lantern slides could be intensified in the same way.

The ordinary platinotype printing process, which has become very well known and widely practiced during the last few years, depends not on the direct influence of light upon platinum salts, but mainly upon its action on certain organic salts of iron, which then react upon the platinum salt.

* See *Photographic News*, 1865, pp. 186–196; and *British Journal of Photography*, March 16th, 1866.

† Report of British Association; Oxford meeting.

‡ *Photographic News*, 1859, p. 251, and *La Lumière*, February 23d, 1856.

Herschel discovered in 1840, that ferric were reduced to ferrous salts by light; that is to say, that under the influence of light iron parts with some of the non-metallic element—oxygen, chlorine, etc., as the case may be—with which it happens to be combined.

Hunt actually tried * to turn this fact to account in photography by mixing ferric oxalate with platinic chloride, and when dry exposing to light. He noticed a slight darkening, but he missed the cardinal point—that the ferrous salt must be in solution before it can act.

It was in June, 1873, that W. Willis, jr., the actual inventor of our platinotype process, took out his first patent for platinotype in England; he patented improvements on it in July, 1878, and in March, 1880. His process is now worked by the Platinotype Company at 29 Southampton Row, High Holborn, London, under the management of Mr. Berkeley. In its latest form, the platinotype paper is prepared by coating paper with a mixture of chloro-platinite of·potassium and ferric oxalate. This is exposed beneath the negative until a faint image is visible, when the paper is floated upon or drawn over a hot solution of potassium oxalate. In this liquid the (reduced) ferrous oxalate is soluble, and immediately it is dissolved it attacks the platinum salt in contact with it, abstracting the chlorine, etc., and reducing the platinum to the metallic state. The advantages of the process are permanency, a beautiful black "engraving-like" picture, simplicity of manipulation and great sensitiveness. Its progress has been retarded—in Great Britain at all events—by the fact that to practice it a license must be obtained from the patentees.

An admirable account of the entire process and its history is contained in a little book written by the Austrian investigators, Pizzighelli and Hubl, and published by Harrison & Sons, Pall Mall, London.†

* See Hunt's " Researches on Light," 1854.
† Price 2 shillings.

CHAPTER XIII.

HISTORY OF ROLLER-SLIDES; AND OF NEGATIVE-MAKING ON PAPER AND ON FILMS.

THERE is nothing new under the sun—especially in photography. Two years ago the introduction of paper negatives and of a roller-slide to match, created quite a *furor* in both England and the "States"; but from 1839 to 1855, or thereabouts, every English amateur used paper as the support for his "calotype" pictures; and the roller-slide is at least thirty-three years old.

Melhuish's Roller-Slide.—The first account of a roller-slide which we have been able to discover, is contained in a patent taken out in England by J. B. Spencer and A. J. Melhuish, on May 22d, 1854. The specification describes how "a series of photographic pictures may be obtained in succession upon a long sheet of sensitive paper, the parts of the paper or sensitive surface not in use, being rolled up within the frame of the camera. The frame in which the prepared surfaces are employed is fitted up with two rollers; in using the apparatus after one picture has been taken, that part of the prepared sensitive surface is wound up on to one of the rollers, and a fresh quantity of the prepared surface suitable for receiving another picture is unwound off the other roller, and so on till all the prepared paper or surface on the roller has been used. Two rods or tubes of yellow glass are employed to retain the part of the sensitive surface which for the time being is brought into position in the correct plane or position. It is preferred to focus directly on to the prepared surface when using waxed paper (instead of focusing on to a plate of ground glass), a plate of yellow glass having previously been placed in front of the lens to prevent the light from injuriously affecting the surface, and a plate of yellow glass is also placed behind the paper for the same purpose."

The fact of the focusing being effected upon the paper coated with silver iodide and protected only by yellow glass, shows how comparatively insensitive to light were the materials then employed. A defect in Melhuish's slide was the apparent lack of any mode of registering when sufficient paper had been wound off one roller on to another to allow a fresh exposure. It is clear that it does not suffice to simply count the number of turns of the roller on to which the paper is wound, since that roller continually increases in thickness. Still, as the long band of paper was composed of a *number of sheets gummed together*, it was possible to *see* when one sheet had been completely rolled up by looking in at the back of the camera.

In the *Journal of the Photographic Society* for April 21st, 1856, there is a letter from Mr. Melhuish giving an account of his slide, and stating that "my best specimens at the Exhibition were taken with the roller-slide. It has been used by James Glaisher, Esq., F. R. S.; John South, Esq., of St. Thomas' Hospital, and Frank Haes, Esq., who have expressed themselves satisfied with its performance." In the drawings which accompany this note we see that the rollers were placed one on each *side* of the camera, instead of one on top and one below as in all other roller-slides.

But in 1854 the roller-slide was "before its time," and its use was probably confined to the three or four gentlemen named above.

Captain Barr's "Dark-Slide."—It is singular that at the very time that Melhuish was striving to introduce his roller-slide to the notice of English photographers, an amateur worker in India—Captain Barr—had devised and was using a very similar instrument, being led thereto probably by the necessity for the lightest and most compact form of apparatus which could be constructed in order to overcome the difficulties of transport which presented themselves in many parts of that country. A description of this very original "dark-slide" —as Captain Barr called it—appeared in the first number of the *Journal of the Photographic Society of Bombay*, and was reprinted in *Notes and Queries* for April 21st, 1855. It consisted of a narrow box made to fit the back of the camera, and

containing an upper and a lower roller, between and in front of which a plate of glass was placed. The sheets of paper were fastened to a band of black calico, which was then wound on the lower roller, and one end of the calico was strained over the glass and attached to the upper roller. This upper roller was actuated by a key which was worked from the outside, and so the calico, etc., could be drawn from the lower to the upper roller as desired. The axis of the lower roller also passed through the side of the box, and was provided on the outside with a short index-roller of precisely the same diameter as the roller within. On this index-roller a piece of tape equal in length to the calico band, was wound, so that it was easy to judge of the amount of sensitive paper used by the length of tape unrolled. Another valuable precaution is given, by Captain Barr, "as a further precaution against light, and to guard against the evil effects of air upon the prepared paper, I leave the black calico band a *foot longer* than is necessary to carry all the (sensitive) paper. So that when all are wound round the roller, the last five or six plies are plain calico, thus excluding the light." It is remarkable that a correspondent of the *Photographic News*, in 1886, suggested exactly the same thing for the Eastman rolls, but his claim to originality is clearly *barr'd* by this paper written thirty-one years ago! Captain Barr adds another most valuable precaution which is to-day well worthy the attention of travelers in hot and moist climates: " I take the roller thus prepared out of the dark-slide and place it in a round metal case, which has a top which screws on air-tight ; in the center of this top is a short tube, opened and shut air-tight at pleasure by a small stop-cock ; to this tube I attach a small suction-pump, and after all is thus prepared, I introduce the roller with the exposed paper into the metal tube, screw on the top, and exhaust the air. Lastly, shut the cock and remove the exhaust-pump."

A fortnight after the appearance of Capt. Barr's paper in *Notes and Queries*, a Mr. T. E. Merritt, of Maidstone, claimed in the same periodical that he had " last year invented a camera with roller almost precisely similar to that of Capt. Barr, but somewhat more simple, inasmuch as I use a roller which by *one turn* winds off the entire picture, and brings

another into its place." Surely Mr. Merritt's roller must have been of a disproportionate diameter!

Warnerke's Roller-Slide.—From 1855 we pass to 1871,[*] when M. Leon Warnerke—a Hungarian engineer, who has done so much good work in England that he may be fairly claimed as an English photographer—invented what was perhaps the first really practical roller-slide. M. Warnerke appears to have published the first account of his roller-slide in the middle of 1875.[†] He writes: "The principal components of the new dark-slide are two rollers on which the sensitive film is wound, and there is room for one hundred plates. A darkened glass plate is fixed in the front, in the place corresponding with the focusing surface; this glass plate guides the sensitive film in the progress from one roller to the other, and secures its proper position. Each roller has a metallic head by which it can be put in motion. By means of these heads all the ribbon of sensitive film can be consecutively drawn from one roller, and, after exposure, rewound on another roller. But to secure perfect flatness there is attached to each head a pressing screw, that arrangement permitting the stretching of the film when in position. Before the sensitive film is attached to the roller, it is divided into sections corresponding with the size of the plates by black lines drawn in pencil, or otherwise, and each section is numbered.

"In the sliding shutter there is a little window secured with orange glass and spring metallic shutter. Through the orange glass I am able to observe the black lines forming the divisions between the plates, and their corresponding numbers. This permits me to judge of the proper position of each consecutive plate."

In 1875, M. Warnerke's paper or tissue was coated with collodion emulsion. Our more sensitive gelatine emulsion does not permit observation through an "orange window," so that in the improved form of M. Warnerke's roller-slide which he introdnced in 1885, he used first an electrical alarm, then a

[*] In the "Photographers' Annual," issued by A. H. Wall, for 1870, there is a sketch of an ingenious roller-slide, designed by T. Wiseman.

[†] *British Journal of Photography,* 1875, p. 306.

spring indicator, and, lastly, a measuring roller with indicator outside.*

Modern Forms of Roller-Slides.—The idea of the roller-slide is, as we have seen, essentially English. But it was reserved for the American firm of Eastman, Walker & Co. (of Rochester, N. Y.), to step in and achieve a commercial success where Melhuish and Warnerke had failed. This was done by the introduction of an admirably designed roller-slide of excellent workmanship—machine-made, with all its parts interchangeable—the details of which were first published in the summer of 1885. The success of the Eastman apparatus has been mainly due to the facts (1) that the roller-slide and the sensitive paper which it was to carry were put into the market together and by the same firm; (2) that the roller-slide was designed by skilled engineers; thoroughly tested before being offered for sale, and excellent workmanship invariably put into it.

Other roller-slides, all showing ingenuity, have been patented during 1885–87 by Messrs. Morgan and Kidd (of Richmond), S. McKellen, and J. E. Thornton (of Manchester), and by several others. But these are "creatures of to-day"; things whose descriptions still linger in our ears. Our main object here has been to draw attention to the past, and to show that the roller-slide—like most other inventions—did not spring into being perfect and full-fledged, but that it was first devised more than thirty years ago by Melhuish and by Barr; then improved by Warnerke; and finally, we may say, perfected by Eastman and others.

Re-introduction of Paper for Negative-making.—We have seen that Fox-Talbot employed paper solely as the support for the sensitive salt of silver (the iodide) which he used in his calotype process—so largely worked by amateurs from 1841 to 1855, or thereabouts. By this method the silver iodide was literally formed within the paper, and was much a part of it as if it had been mixed with the pulp when the paper was made. The effect of this was that, except in the largest sizes, the "grain" of the paper was disagreeably evident in the fin-

* *British Journal of Photography*, 1885, p. 601.

ished print; and, although the waxing of the paper before
sensitizing, an improvement due to Le Gray, tended to obviate
this by filling the pores of the paper, and so keeping the pic-
ture more or less on the surface, yet it was only a partial
remedy.

However, the beauty, and above all the rapidity of Archer's
collodion process on glass was such, that in a very few years
after its introduction in 1851, it knocked paper out of the
field altogether, and for negative-taking, glass coated with col-
lodion was almost exclusively used from 1851 to 1880, and
glass coated with gelatine from 1880 to 1885. In the last-
named year paper once more came prominently to the front.

Blanchard's Enlarged Negatives.—In 1875, Valentine
Blanchard used paper for making enlarged negatives in the
following way. He made an enlarged transparency in the
camera, and from this took a deep print (which, of course,
would be a negative), which he waxed to increase its trans-
parency, and used as an ordinary negative. In artistic hands
this method offers great facilities for introducing effects, as re-
touching, etc., can be done both on the transparency and on
the enlarged negative.

Gelatino-Bromide Paper for Negatives.—After the com-
plete success of gelatino-bromide emulsion spread upon glass,
in 1879–80, it was but natural to endeavor to apply the same
material to paper. W. T. Morgan, of Greenwich, placed
paper coated in this way in the market early in 1880, intend-
ing it mainly to be used for printing by development, after
the manner suggested by Abney in the same year.*

But Palmer, Ranking, and other amateurs saw the possibili-
ties of the new material, and, cutting the paper to fit their
dark-slides, used it for work in the field. The manufacturers
took the hint, and in 1884 made a more sensitive paper, in-
tended specially for negative work. Then in the summer of
1885, the Eastman Company's negative paper was introduced
simultaneously in England and the United States, and from
the care and skill displayed in its manufacture, at once took a
leading position. It is now very largely used, both in roll-

British Journal of Photography, pp. 103, 160.

holders carrying enough material for twenty-four exposures, and, cut to size, in carriers which fit the photographer's dark-slides. The secret of the beautiful results produced upon the "negative paper" now made consists in isolating the emulsion of silver bromide from the paper by giving the latter a preliminary coating of gelatine, the emulsion being thus kept on the surface. After development the paper negatives may either be printed from as they are, or they may be rendered more transparent by soaking in oil vaseline.

As a method of abolishing the "grain" of paper negatives, Warnerke patented in 1885, a process for covering a paper with emulsion on *both sides*, so that any imperfections on one side were corrected by the image on the other, "rendering the composite negative perfectly smooth, no matter how coarse or imperfect was the texture of the paper employed."

Lastly, in 1885, that inventive genius, Walter B. Woodbury, made paper transparent by soaking it in a solution of gum-dammar in benzole, after which it was coated with emulsion in the usual way. This paper, or "tissue," is now manufactured in London by Mr. Vergara, who has invented an ingenious double dark-slide to hold the tissue.

Film or "Tissue" Negatives.—Very early in the history of photography the possible benefits to be derived from removing the film bearing the picture from its glass support were recognized.

In August, 1855, Scott-Archer patented a method of coating collodion negatives with a solution of gutta-percha in benzole. When dry, separation of the film from the glass was obtained by soaking in water. The glass might also receive a preliminary coating of gutta-percha, in which case the collodion film was enclosed between two waterproof films.

In the same year (1855) the Frenchman Galliard coated collodion negatives with gelatine, and then stripped them from the glass. In 1877, J. R. Johnson patented the application of a double coating of collodion and gelatine for the same purpose.

In 1869, Leon Warnerke commenced the preparation of sensitive collodio-bromide tissue, which was introduced into commerce in 1875. A film of collodion as transparent and

textureless as glass was produced upon enameled paper, and this was coated, first with India rubber and then with collodion emulsion.

After gelatine had displaced collodion, Warnerke (in 1885) manufactured a similar article, using gelatine in place of collodion, but in neither form can Warnerke's tissue be said to have come into general use.

A notable discovery made by Warnerke, and patented by him in 1881, is that an exposed gelatine film developed with pyrogallic acid becomes insoluble in hot water in the parts affected by light. If it is soaked in warm water and squeegeed upon a glass plate, the paper can be stripped off, and the soluble gelatine washed away, leaving a reversed negative attached to the glass. Great things were expected of this process at the time of the discovery, but practically no use has been made of it.

In 1881, H. Rogers showed how to strip negative films by varnishing them with gum-dammar dissolved in chloroform, and then soaking them in water.

The book on " Retouching," published by Burrows & Colton in 1876, has for frontispiece an excellent " pellicular negative," apparently consisting of a film of collodion coated with gelatine.

The late W. B. Woodbury used, during the collodion times, a method by which glass was *partly* superseded, the same glass plates being used day after day. The glass was rubbed with talc, and then coated with collodion emulsion. After exposure these plates were developed, fixed, and washed, and a sheet of gelatine paper was squeegeed to the finished negative. When dry, the whole could be peeled off the glass, which was then ready for use again. At any convenient time the paper bearing the film was wetted and squeegeed down to a glass plate coated with insoluble gelatine. Finally the whole was soaked in warm water, which dissolved the upper layer of soluble gelatine, and the paper was stripped off, leaving the negative permanently attached to the glass.

In 1881–82, Stebbing, of Paris, and Pumphrey, of Birmingham, introduced sheets of gelatine made insoluble by a little h rome alum, and coated with gelatine emulsion. Pumph-

rey's "Filmo-graph," as the camera adopted for use with these films was called, was a really ingenious instrument, carrying a hundred films with ease.

The Eastman "stripping films," which we first saw in the summer of 1885, are now just coming into use. They consist of a film of *insoluble* gelatine emulsion attached to a sheet of paper by a thick layer of *soluble* gelatine. After the film has been exposed and developed in the same manner as a gelatine plate, it is squeegeed, face downwards, on a glass plate coated with India rubber solution, allowed to dry, and is then placed in hot water, when the soluble gelatine is dissolved and the paper can be readily stripped off, leaving the insoluble gelatine film firmly on the glass. Finally, a "skin" of prepared gelatine is moistened and squeegeed upon the negative, which, when dry, is easily stripped, as a whole, from its glass support.

Films upon Card-board.—In 1883, Thiébaut, of Paris, patented a method of coating gelatinized paper first with collodion (hardened by a little castor oil), and then with a gelatine emulsion. Such films could be stripped *dry* from the paper support after exposure, development and fixing. Thiébaut, in 1885, substituted card-board instead of paper as a support for the emulsion.

In 1886, Pumphrey, of Birmingham, manufactured gelatine films, which were placed upon a support of thin ebonite covered with some adhesive substance for exposure in ordinary dark-slides. In 1887, he used card-board as the support, and the film (known as "flexible glass") is stripped *before* development. The films are developed and fixed as easily as glass plates; they are then dried on card-board, varnished, and remain flat and highly transparent.

Advantages and Disadvantages of Paper and Films.— The principal advantage of paper or films over glass for negative-making is, of course, their comparative *lightness*. This is most felt with the large sizes—whole plate and upwards—and is an especial boon to travelers and tourists. Then there is a marked absence of the halation or blurring which is so common upon glass, surrounding brightly-lit objects, or windows, etc., with a mist or halo of light. Paper negatives are also unbreakable, flexible, and can be stowed away in a very small

space. They can also—owing to their thinness—be printed *from either side*, thus obviating the necessity in certain processes of producing a reversed negative. From several paper negatives it is easy to form, by careful cutting, a single *combination negative* which shall unite the good qualities of each of its components.

The disadvantages of paper are not many; it is not quite so easy to manipulate as glass; not being so transparent it does not yield prints so quickly; and no thoroughly satisfactory mode of varnishing paper negatives has yet been announced. The "grain" visible in many paper negatives has already been alluded to; lastly, it is not so easy to get good lantern-slides from paper as from glass.

Balancing these points, good and evil, it is probable that glass will retain its pre-eminence for studio work and for small pictures; while by those who travel and who desire to take good-sized pictures, paper or films will certainly be preferred.

CHAPTER XIV.

HISTORY OF PHOTOGRAPHY IN COLORS.

THERE is probably only one thing which it is safe to predict about the problem of obtaining permanent photographs which shall represent objects in their natural colors, and that is that the discovery, if it is ever made, will not be the result of an accident. The question must be studied and the conditions mastered before the attempt can be made with even the least chance of success. The following account is given with the hope of drawing attention to the progress which has already been made, whence it will be seen that, with regard to naturally colored pictures, we are now precisely in the position occupied by Davy and Wedgwood with respect to ordinary photographs at the commencement of the present century. Davy could obtain copies of objects upon paper coated with silver chloride (1802), but he could not fix them. Similarly it has been possible for many years, certainly since 1848, to obtain naturally colored photographs; but no certain means have yet been discovered by which they can be rendered permanent. The colors fade away when the pictures are exposed to light; or when they are treated with the ordinary "fixing agents" of the photographer. When will the Niepce, the Talbot, or the Herschel arise who will do for colors what these "fathers of photography" did for pictures in black and white?

Seebeck's Experiment, 1810.—Early in the present century an observation was made which favors the views of those who believe in the possibility of reproducing, photographically, the natural colors of bodies. In 1810 Dr. Seebeck, of Jena, was engaged in repeating certain experiments, first made by Ritter in 1801, upon the existence of the ultra-violet rays. For this purpose Seebeck passed a beam of white light through a prism and received the spectrum, or band of colored light so

produced, upon a sensitive surface of chloride of silver. Upon this substance he was afterwards surprised to see distinct traces of color. Describing the experiment in the *Farbenlehre* of Göethe, Seebeck writes : " When a spectrum produced by a properly constructed prism is thrown upon moist chloride of silver paper, if the printing be continued for from fifteen to twenty minutes, whilst a constant position for the spectrum is maintained by any means, I observe the following : In the violet light the chloride becomes a reddish-brown (sometimes more violet, sometimes more blue), and this coloration extends well beyond the limit of the violet. In the blue part of the spectrum the chloride takes a clear blue tint, which fades away, becoming lighter in the green. In the yellow I usually found the chloride unaltered ; sometimes, however, it had a light yellow tint. In the red, and beyond the red, it took a rose or lilac tint. This image of the spectrum shows beyond the red, and beyond the violet, a region more or less light and uncolored."

Observations of Herschel, Daguerre and Talbot.—In 1839, Sir John Herschel also noticed the colors produced on sensitive surfaces by the action of colored light. He found that " the spectrum impressed upon a paper spread with the chloride of silver is often beautifully tinted, giving, when the sunshine has been favorable, a range of colors very nearly corresponding with the natural hues of the prismatic spectrum. The mean red ray leaves a red impression, which passes into green over the space occupied by the yellow rays. Beyond this a leaden blue is discovered." Daguerre noticed that a red house gave a reddish image on his iodized silver plates in the camera, and at an equally early date Fox-Talbot observed that the red portions of a colored print were copied of a red color on paper prepared with chloride of silver.

Hunt Obtains Photographs Colored by Light.—Between 1840 and 1843 Robert Hunt tried many experiments on the production of colored images by light. By dipping paper first into nitrate of silver, and then into sodium fluoride, he obtained a thin coating of silver fluoride. When this paper was exposed to the spectrum " the action commenced at the center of the yellow ray, and rapidly proceeded upwards, ar-

riving at its maximum in the blue ray. To the end of the indigo the action was pretty uniform; it then appeared to be very suddenly checked, and a brown tint was produced under the violet rays, all action ceasing a few lines beyond the luminous spectrum. The colors of this spectrum are not a little remarkable. I have now before me a spectrum impressed two months since, and the colors are still beautifully clear and distinct. The paper is slightly browned by diffused light, upon which appears the following order of colors: A yellow line distinctly marks the space occupied by the yellow ray, and a green band the space of the green; through the blue and indigo region the color is an intense blue, and over the violet a ruddy brown." Although this description is not very clear, it seems to point to two modes of treatment of the sensitized paper. The colors were only obtained in the second case, when the paper had been insolated, or exposed to light for a short time before the spectrum was allowed to fall upon it.

Other results obtained by Hunt are recorded as follows:[*] "A paper prepared by washing with barium chloride and nitrate of silver, allowed to darken whilst wet to a chocolate color, was placed under a frame containing a red, a yellow, a green, and a blue glass. After a week's exposure to diffused light it became red under the red glass, a dirty yellow under the yellow glass, a dark green under the green, and a light olive under the blue."

In another experiment tried in 1843, with paper prepared with bromide of silver and gallic acid, "the camera embraced a picture of a clear blue sky, stucco-fronted houses and a green field. The paper was unavoidably exposed for a longer period than was intended—about fifteen minutes. A very beautiful picture was impressed, which, when held between the eye and the light exhibited a curious order of colors. The sky was of a crimson hue, the houses of a slaty blue, and the green fields of a brick-red tint." Hunt adds: "Surely these results appear to encourage the hope that we may eventually arrive at a process by which external nature may be made to impress its images on prepared surfaces in all the beauty of their native coloration."

[*] "Researches on Light," 1844, p. 277.

*Becquerel's Experiments in Color Photography.**—Perhaps
the most successful reproductions of color by means of pho-
tography which have ever been made, were obtained by the
French physicist, Edmond Becquerel, in 1848. Taking a sil-
ver plate, such as is used in Daguerreotype, he obtained a thin
and very uniform coating of chloride of silver upon its surface.
This he sometimes effected by soaking it in chlorine water
until the silver assumed a rose tint, or by dipping it into solu-
tions of cupric or ferric chloride. By preference, however,
Becquerel placed the silver plate in a solution of hydrochloric
acid, and attached to it a wire from the positive pole of a vol-
taic battery; the wire from the negative pole being fastened
to a plate of platinum, which also dipped into the acid solu-
tion. By this means the hydrochloric acid was decomposed,
and the chlorine being drawn by electrical attraction to the
silver plate, combined with it chemically, forming a surface of
silver chloride of great purity. As the combination of silver
and chlorine took place, the layer of silver chloride gradually
increased in thickness, and as it did so its color changed to
gray, yellow, violet, and blue; and, continuing the action,
these colors appeared a second time. When the second violet
tint had been obtained, the silver plate was withdrawn from
the solution, washed and dried, and gently heated until the
surface assumed a rosy hue. When the spectrum of sunlight
or of the electric arc was received upon a plate so prepared,
an exposure of a few minutes was sufficient to impress the
diverse colors. Colored images of bright dressed dolls were
also obtained.

Failure in Fixing Colored Images.—After Becquerel had
obtained such favorable results, it may be asked, how is it that
further progress has not been made, and why are not colored
photographs more frequently produced? The answer is that
no certain means has hitherto been found of *fixing* the colored
images secured; they can only be examined in a faint light,
and must be kept locked up in drawers and excluded from the
day. They last longer when protected from the air, for oxy-

* See "Comptes Rendus," 1848 and 1854; also "Annal de Chimie,"
1849.

gen has a detrimental effect upon the colors. Becquerel, however, appears to have succeeded in rendering more or less permanent *some*, at any rate, of his "heliochromes." One which he presented to Brewster was lent by the latter to J. Traill Taylor, who exposed it for several days to *bright sunshine* without injury to the colors.*

Experiments of the Younger Niepce.—Niepce de St. Victor repeated Becquerel's experiments, but he found it better to form the chloride of silver by immersing the silver plate in a solution of chloride of lime.† He also reduced the time of exposure by coating the chlorinized surface with a solution of chloride of lead in dextrine. Niepce believed that a relation existed between the colors impressed and the source from which the chloride was obtained; and in 1857 he published the results of some experiments on the connection between the colors imparted to flame by certain metallic chlorides, and the colors impressed on silver plates prepared from the same chlorides. Subsequent investigations have not, however, confirmed this theory. Niepce sent specimens of his work to the London Exhibition of 1862, consisting of about a dozen reproductions of prints of figures with parti-colored draperies. Each tint in the pictures exhibited was a faithful reproduction of the original, including yellows, blues, reds, greens, etc., all very vivid. Some of the tints faded at once when these pictures were examined by daylight, but others remained for some hours.

Poitevin obtains Colored Copies on Sensitive Paper.—In 1868,‡ A. Poitevin examined and extended the results obtained by Herschel and Hunt. Taking paper sensitized in the usual way with silver chloride, he washed it and exposed the sensitive surface to light for a short period. The insolated paper was then dipped into a solution containing bichromate of potash and copper sulphate, and finally dried. When such paper was exposed to light beneath a transparent colored picture—as a painting on glass—the colors of the pictures were

* *British Journal of Photography*, December 29th, 1865.
† Series of papers in *Comptes Rendus*, 1851 to 1863.
‡ *Comptes Rendus*, 1868, vol. lxi., p. 11.

reproduced on the paper. Poitevin states that the colors so obtained could be fixed by means of sulphuric acid.

Another French experimenter, St. Florent, in 1874, described* a method of obtaining similar results in a rather different manner. Paper is soaked first in silver nitrate, and then in a mixture of uranium nitrate and zinc chloride, rendered acid with hydrochloric acid. The paper is dried and exposed to light until the surface is slightly darkened; it is then floated on a solution of mercuric nitrate, again dried, and is then ready for exposure to the colored light whose impression it is desired to secure.

Colored Copies obtained with Paper—Abney's Researches. —With reference to colored images obtained upon paper, Captain Abney remarks :† " It must not be forgotten that pure salts of silver are not being dealt with as a rule. An organic salt of silver is usually mixed with chloride of silver paper, this salt being due to the sizing of the paper, which, towards the red end of the spectrum, is usually more sensitive than the chloride. If a piece of the ordinary chloride of silver paper is exposed to the spectrum till an impression is made, it will usually be found that the blue color of the darkened chloride is mixed with that due to the coloration of the darkened organic compound of silver in the violet region, whereas in the blue and green this organic compound is alone affected and is of a different color from that of the darkened mixed chloride and organic compound. This naturally gives an impression that the different rays yield different tints, whereas this result is simply owing to the different range of sensitiveness of the bodies."

But the colored images obtained upon daguerreotype plates by the method of Becquerel must be truly due to the distinct effects of different rays of light, for in that case there is no organic compound present to interfere with the results.

Acting on a suggestion made in December, 1865, by the then Paris correspondent of the *British Journal of Photography*, R. J. Fowler (formerly of Leeds), several trials were made by English experimentalists, and in particular by J.

* In the *Bulletin de la Société Française de Photographie.*
† " Encyclopædia Britannica," vol. xviii., p. 835 (ninth edition).

Traill Taylor and G. Wharton Simpson, in the course of the following year, to utilize collodio-chloride of silver films in obtaining colored images. The colors obtained were not so vivid as those secured by Becquerel upon daguerreotype plates, but they were visible by transmitted as well as reflected light.

Pretended Discoveries of Photography in Colors.—A year seldom or never passes without the announcement in some newspaper or other that " Photography in colors is at last an accomplished fact!" In some cases the " discovery " merely relates to a modification of the well-known mechanical process by which—several negatives being employed—the picture is printed piecemeal, each portion receiving a daub of a separate color. Frequently the method adopted is to render the photograph transparent and color it on the back; some such plan has been patented on an average twice a year for the last twenty years!

Other reputed "discoveries" are due to the fact that by faulty manipulation, colors of some kind or other are not unfrequently obtained upon collodion—as in Hunt's example— or even on gelatine plates; or they may be the result of a splitting of the film, giving the " colors of thin plates." Some novice noting these, to him, marvelous appearances, writes in haste to the papers that he has secured the long-wished-for result—a result, however, which he finds himself unable to reproduce.

Still other cases are deliberate frauds. Thus, in 1851, an American preacher named Hill, obtained almost general credence for his statement that he could produce photographs "glowing with all the colors of nature!" Naturally, so wonderful a process was to be called Hillotype. The Rev. Mr. Hill obtained a considerable sum of money by inducing photographers generally to subscribe— payment in advance, of course—for a book which should contain all the details of this startling discovery. After many delays the promised book appeared ; but what was the disappointment of the subscribers to find it a mere two-penny pamphlet containing the outlines of the Daguerreotype process, with complications and additions just sufficient to render the obtaining of any picture at all a very improbable matter!

Origin of the Colors obtained upon Salts of Silver.—The most recent researches upon photography in colors are those of Captain Abney.* He states that the colors obtained by Becquerel and others upon Daguerreotype plates are due to the oxidation of the silver compounds employed. When the sensitive plates are exposed in the presence of some oxidizing agent, as by dipping them into peroxide of hydrogen before or during exposure, the colors are produced more speedily.

The same investigator points out that there are several known molecular combinations of bromide of silver, which can readily be distinguished from each other by the fact that they absorb different rays of light.

Thus we are acquainted with:

(1) A modification of silver bromide which transmits and reflects orange light. This form of the silver bromide molecule exists in paper which has been sensitized with silver bromide, on plates coated with a collodio-bromide film, and on collodion-bath plates. This molecule will clearly be chiefly affected by the blue rays, since it absorbs the blue end of the spectrum, and work is done only by those rays which are absorbed.

(2) Another form of the silver-bromide molecule appears of a bluish-green tint, by transmitted light. This modification absorbs the light of the red end of the spectrum, and even the invisible or "dark heat" rays which lie beyond the red. By taking advantage of this property, Captain Abney was enabled to obtain photographs of the region called the "ultra red," which proved its extension over a length exceeding that of the whole of the spectrum ordinarily visible.

(3) Silver bromide contained in emulsions which have been boiled, or treated with ammonia, appears of a gray tint by transmitted light.

By an exposure of two minutes to the band of colored light, produced by passing a beam of white light through a spectroscope, Abney obtained colored pictures of the solar spectrum upon silver (Daguerreotype) plates, and upon collodion films.

* "Proceedings of the Royal Society," 1879, vol. xxix., p. 190 ; vol. xxxiii., p. 164.

He considered the colors obtained to be due to the mixture, upon the same plate, of the first two modifications of the silver-bromide molecule described above; the first absorbing the light of the blue, and the second that of the red end of the spectrum.

The admirable researches of Carey Lea upon the "photo-salts" of silver, published in the *American Journal of Science*, during 1887, constitute an important advance, and their author believes that the new substances which he has discovered and isolated, will ultimately furnish the key to the question of photography in colors.

But still the original problem confronts and baffles us. No means are known of giving permanence to the size or form of these color-producing molecules; indeed, the molecules are themselves decomposed, or radically altered, by the ordinary "fixing agents" employed by the photographer.

Under the influence of white light also the colored molecules of silver bromide change; they are decomposed and the colors disappear. And after all, the colors which we have as yet been able to obtain, but not to fix, by means of photography, are but faint and dim, poor reflections of the brilliant tints of nature.

In this work of obtaining naturally-colored photographs there is clearly a fine field for experiment and research. How many photographers have attempted even to confirm the results obtained by Becquerel, Niepce, Carey Lea, and Abney? And yet what an interesting and important task this would be.

The references given above will enable anyone who has access to a good library, such as our leading photographic societies ought each to possess, to ascertain more fully the details of working.

CHAPTER XV.

HISTORY OF THE INTRODUCTION OF DEVELOPERS—SUMMING UP.

A Brief History of Development.—1. In Niepceotype the picture was "brought out" by simply washing the exposed bitumenized plate with a solvent, which washed away those portions of the asphalt that had not been acted on by light (1827).

2. A Daguerreotype was developed by causing the vapor of mercury to act upon a surface of silver iodide; the metallic vapor condensed on those places where the light had acted, in proportion to the intensity of the light (1839).

3. The developer for calotypes was a mixture of gallic acid and silver nitrate. The former of these bodies is a powerful *reducer ;* i. e., it is able to separate the metallic silver in the silver nitrate from the other substances with which it is combined. This newly-liberated silver is *attracted by* those portions of the sensitive surface upon which the light has acted, and is deposited upon them in the exact ratio of the intensity of the light (1841).

4. Archer (in 1851) developed his collodion plates by pouring on them a mixture of pyrogallic acid and acetic acid in water. The action was precisely the same as in the calotype process; and, as the wet collodion film was already covered with nitrate of silver, there was no necessity to add more of that substance to the developer. Ferrous sulphate (first used by Robert Hunt in 1844) was frequently employed instead of gallic or pyrogallic acid as a silver reducer in the wet collodion process.

5. For our modern dry-plate work all the developers described above have been displaced by what is known as "alkaline development," in which the developer consists of pyrogallic acid, ammonia, and ammonium bromide, dissolved in water. The ammonia exercises a stimulating action upon the pyro, while the ammonium bromide prevents any action on the

parts of the silver bromide which have not been affected by light The silver to form the image is obtained from the silver bromide embedded in the gelatine, or in the collodion with which the plate is coated. Light acts upon certain of the surface molecules of this silver bromide, displacing some or all of the bromide, and leaving (let us say for simplicity's sake), scattered molecules of silver to bear testimony to its action. Yet, upon removing an exposed plate from the camera, no picture is visible upon its white surface. The reason is that the isolated particles of silver are too small and too few to be visible ; just as a handful of shot could not be detected by the eye if mixed with a sack of flour. But under the stimulus of the alkaline developer the reduced silver molecules attack the molecules of silver bromide *beneath* them, abstracting their silver, and this action goes on until " the high-lights " become visible at the back of the plate, by which time it is, as a rule, sufficiently developed to give a dense image after " fixing," as we call the process of clearing away the unacted-on silver bromide.

The alkaline developer appears to have had its inception in America. In 1862, the news reached England that Messrs. Anthony and Borda had found great benefit in fuming dry-plates with ammonia before development. At the same time Mr. Leahy, of Dublin, found that a little liquid ammonia added to a plain pyrogallic acid developer brought out the image very rapidly. But Major Russell, the author of the tannin process, had for some time been at work in the same direction, and in the second edition of his book on the " Tannin Process," published in 1863, we find the first complete account of a workable system of alkaline development. Russell not only described the accelerating action of ammonia, but he showed the necessity for the presence in the developer of a soluble bromide, in order to prevent fog. Since 1862, the carbonates of ammonia, soda and potash have been used in turn as the alkaline element of the developer in place of ammonia, but the latter still retains most votaries in England, although the fixed alkalies (soda and potash) find great favor in America.

6. In 1877, Carey Lea, in America, and Willis, in England, simultaneously announced that ferrous oxalate formed an ad-

mirable developer for plates containing bromide of silver. Ferrous oxalate is best made by pouring one part, by measure, of ferrous sulphate into three parts, by measure, of potassium oxalate, both the solutions being saturated. This developer has found great favor on the Continent. It gives clean plates, but there is not the same power of remedying an incorrect exposure as with pyro and ammonia.

Scores of other developers have been proposed, which the limits of our space forbid us referring to in detail.

Advance of Photography.—From what has been written it will be seen that the progress which has been achieved in photography during the brief half century of its existence has been mainly in the direction of *rapidity*. It is not so much that we take *better* photographs in 1887 than in 1839, as that we take them in a fraction of the time then required. The following table shows this very clearly :

Process.	Date of Discovery.	Time required.
Heliography	1827.	6 hours.
Daguerreotype	1839.	30 minutes.
Calotype	1841.	3 minutes.
Collodion	1851.	10 seconds.
Collodion Emulsion Dry-Plates	1864.	15 seconds.
Gelatine Emulsion	1878.	1 second.

The above are average exposures, compared with a certain standard ; but gelatine plates can be prepared to take fully-exposed pictures of brightly-lit landscapes in the two-hundredth part of a second. Perhaps the most rapid exposures made are those by which M. Janssen, the French astronomer, daily takes photographs of the sun at the observatory of Meudon, near Paris, in the two-thousandth part of a second. This rapidity of our modern gelatine plates has led to the invention of a great variety of "shutters," by which the opening admitting light through the camera lens is opened and closed in the fraction of a second. A skillful operator can take off and replace the ordinary "cap" of a lens in the third of a second, but for what are called instantaneous exposures it is necessary to do this in the one-eighth—or less—of a second ; and for this purpose we replace the cap by a shutter.

Conclusion.—And now we are compelled to end our review

of the growth of this young giant, this science of our own time —Photography. We have said much, but we feel how much there is left unsaid. We desired to speak of the improvements in lenses, of the application of photography to the microscope, of astronomical photography, and of several minor topics the history of whose discovery is the best road to their thorough comprehension; but at present we must be satisfied with having traced the "main line" from end to end.

And what lessons there are to be read in this story of the advance of photography. How beautifully it exemplifies the theory of evolution, process rising out of process, and improvement following on improvement, in as orderly, though far more rapid a manner, as the horse has been evolved from the hipparion ! Let it be our task to sustain the rate of progress, and then the photographers of the twentieth century will esteem our labors as highly as we do the work of Niepce and Talbot, of Archer and Daguerre.

APPENDIX.

DR. MADDOX ON THE DISCOVERY OF THE GELATINO-BROMIDE PROCESS.

FEELING that some further details of the discovery of the now universally employed gelatino-bromide of silver process would be of great interest in the history of photography, I wrote to the veteran worker, Dr. Richard Leach Maddox,* to whose labors we are indebted for our gelatine dry-plates, to gain additional information as to the steps by which he was led to the inception of the work which will always be associated with his name. I am sure that the readers of this book will peruse with special pleasure the account which he has given of the work done by him sixteen years ago, which has been so fruitful. Some may feel inclined to wonder that having done so much—having advanced so far on the road to success, and with the goal in view—that Dr. Maddox did not do more, and himself perfect his valuable discovery. To such be it said that for more than half a century Dr. Maddox has borne with patience a painful disease which would have incapacitated most men from all work that was not absolutely necessary. Then the imperative calls of his profession, and the splendid work he has also done in photo-micrography must be taken into account, and when we remember all this, we see that the wonder is not that he did not do more, but that he did so much, and did it so well.

And now we will let Dr. Maddox speak for himself :

"PORTSWOOD, SOUTHAMPTON, August 19, 1887.

Dear Sir—In your favor of the 17th inst. you express a wish "to know more how and why my attention was directed to gelatine and silver bromide?" If you find the answer rather a complex one you must excuse it upon its threefold character.

Firstly the cost of the collodion, with the troublesome manu-

* Born at Bath, 1816.

facture of the cotton. Secondly, health more or less affected by its constant use when working, as I was in my camera, a dressing-room, often at a very high temperature in the summer months; and thirdly, dissatisfaction with the dry methods for the photo-micrographic work upon which I was much engaged.

The first reason may be dismissed as of little moment when there was an adequate return upon the work done; but not so, when there was an absolute loss even in an amateur's point of view. The second reason was a more important one. Being often shut up for hours in the said camera, the temperature at full summer heat, I found the system completely saturated with the vapor of the collodion, so much so that it could be tasted in the breath on awakening in the night, and sleep was generally much disturbed and unrefreshing, while it was much needed to restore the nervous energy wasted by constant suffering, often very severe in character; moreover there was an outcry in the household that the collodion vapor unpleasantly pervaded every room in the house. The third reason was that I could find no satisfactory dry or sticky process that did not embrace the first two reasons, and add another of its own in the shape of additional time and trouble in the preparation of the plate.

These reasons set me experimenting, sometimes on paper, sometimes on glass, with vegetable gummy matters as lichen, linseed, quince seed, and starchy substances as rice, tapioca, sago, etc.; and with waxy material as Japanese vegetable wax. Often I fancied I was just within the doorway when the door closed, and other plans had to be tried. All the literature I could find bordering on the subject was searched, but it rather bewildered than enlightened. At last I turned to the animal series, and wasted many eggs and some little silver; then I went to the finest isinglass at about twenty shillings the pound weight, and the very first experiment led me to hope I was on the right track; something had to be altered, as I was using iodo-bromide in varying collodion proportions, and the isinglass did not appear to yield a sufficiently even surface in spite of all kinds of filtering; yet confidence was felt that a vein had been struck. Search was now made in the house for a

packet of Nelson's gelatine; this afforded a better surface, especially as the plates were dried generally on a hot one-inch-thick iron slab, and tested at once. Then came the mixture of isinglass and gelatine, but the advantages pointed to gelatine. The little plates were tried under a negative, then on out-of-door objects, but it was impossible to get some laurels depicted in anything more than black and white. I remembered that someone had stated that the bromides were better suited than the iodides for foliage—now came the experiment of diminishing the iodide and increasing the bromide until it settled into bromide alone. Yet I was not satisfied; but experimenting went on so rapidly that often I did not wait to filter the gelatine before mixing the bromide of silver in it. Before this period, that talented experimenter, Mr. Carey Lea, had spoken of the use of aqua regia, and my attention was turned to it, fancying that its use would decompose some of the gelatine and furnish the extra silver a chance of forming an organic salt of silver which might possibly improve the image. After working with this and getting more satisfactory results, various substances were mixed with the gelatine, as gum, sugar, glycerine, etc., which gave different tints to the developed negatives, and it was seen that it only required further experimenting to put gelatine into use, for some of the negatives were fairly plucky, and half tones beautifully rendered, but, compared with collodion, the gelatine was slower, although it stood its ground with some of the dry processes.

Paper had not been neglected, for among the paper trials with the gelatine was one which I thought gave much promise, the tint on development equaling much of the kind at the present day. This was obtained by the addition of a small quantity of arsenite of silver.

There was no thought of bringing the subject into notice until it had been lifted from the cradle. Soaking the plates before use, for, of course, I knew the useless salts were left in the gelatine, was noted down for trial; but at this stage, and while in the very hey-day of experimenting, there came an urgent appeal from my kind friend, Mr. J. Traill Taylor, to assist him, without delay, by an article for the *British Journal*

of Photography, of which he was then editor, as he had been taken seriously ill.

Without a moment's hesitation, and thinking it would give my friend pleasure, the hurriedly written and fragmentary article that appeared in the September *Journal,* 1871, was forwarded to him, and proofs by sundry negatives were also sent, some of which, almost entirely defaced, my friend, Mr. W. B. Bolton, and I found three or four years since among the glass in the office at No. 2 York Street. Another pen had also come to the rescue, and my paper was deferred to the following weekly issue, when Mr. Taylor, with far-sighted judgment, noted the process had a future before it.

Health had now fairly broken down, rest was needed, so that very little further experimenting was done; and as there were other irons in the fire demanding attention, the process was offered to a firm in Southampton, from whom I used to get my albumenized paper; but it was found there was no time to continue the necessary experiments to raise the rapidity and enhance its value. This was done at different stages by others, almost two years after I had freely given to the public what had cost me much time and labor.

The world has been benefited and I have been honored with a gold medal and diploma by the Jurors' Committee of the Inventions' Exhibition. Do not for one moment suppose I ignore the work of other hands in *perfecting* the gelatino-bromide process, and thus giving it its world-wide value in all departments of photography, especially that far-reaching one of its adaptation to astronomical research. I am only too thankful to feel that I have been merely the stepping-stone upon which others have safely put their feet, though now and then there cropped up the old story of the prophet in his own country— let it pass, this is the jubilee year. I am grateful to those abroad and at home who like yourself have recognised the original claim of

Dear sir, yours most truly,

R. L. Maddox.

W. Jerome Harrison, Esq., Birmingham.

A BIOGRAPHIC SKETCH OF THE AUTHOR.

By W. I. Lincoln Adams.

William Jerome Harrison, the bibliographer, as well as historian of photography, was born at Hemsworth, in Yorkshire, March 16th, 1845. While still a child, he accompanied his parents to Australia, a journey undertaken in the hope of improving his father's health, who, however, died shortly after his arrival there. Returning to England, young Harrison was educated—with a special view to his joining the scholastic profession—for seven years at the Westminster Training College, and afterwards for two years at Cheltenham. He left Cheltenham College as senior prizeman, and holder of the highest obtainable government certificate, and was shortly afterwards appointed head master of a large boys' school in Leicester.

Mr. Harrison's scientific education may be said to have commenced in 1868, when he began to study for the examinations of the science and art department. Within the next ten years he carried off the highest distinctions in chemistry, physics, geology and physical geography, being double gold medalist (by marks) in the last two subjects in 1872. During these years he spent much time in the laboratories of the government science schools at South Kensington, under Professors Frankland, Valentin, Huxley, Guthrie, Judd, etc.

In 1872 Mr. Harrison was appointed chief curator of the Leicester Corporation Museum, in connection with which he established very large and successful science classes. His original work at this time was done mainly in connection with geology. He was elected a Fellow of the Geological Society in 1876, and received repeated grants from the Royal Society to enable him to prosecute geological researches.

In 1876 he published a "Manual of Practical Geology," but his most important book in this line is the "Geology of the Counties of England and of North and South Wales,"

which appeared in 1882, and at once was recognized as a standard work. The establishment of the school board system, in 1870, revolutionized educational matters in England. When the new boards got fairly to work, those of the great manufacturing towns recognized the importance of science as a branch of education, and in 1880 Mr. Harrison received the important appointment of Science Demonstrator to the School Board of Birmingham, a town with a population of half a million, situated in the very center of England. With a large staff of assistants, well appointed laboratories, and a technical school, he has the direction of the scientific studies of about six thousand of the elder children, and of some hundreds of the younger teachers.

For his success in the organization of this work, Mr. Harrison was awarded a medal by the Society of Arts in 1881. For continued work in geology he received the Darwin Medal in 1884, and at the recent meeting of the British Association in Birmingham, he acted as Secretary of Section C (Geology), to which he also contributed several papers. He is also a frequent contributor to the *Cornhill*, *Knowledge*, *The National Dictionary of Biography*, etc.

In photography Mr. Harrison is essentially a "dry-plate man," not having commenced practical work in the art-science till 1881. He has devoted his attention mainly to the historical and scientific side of the subject, and his researches on the "Literature of Photography" have resulted in the publication, for the first time, of a complete list of English books on the subject, embracing more than three hundred works by about half as many authors.

In this "History of Photography," Mr. Harrison has given the condensed results of his study of the contents of these books ; but he has also collected a great mass of information in the form of all the "papers" on photography which have appeared in general literature during the past half century, together with the numerous periodicals which have been issued in connection with the science.

Mr. Harrison's favorite implement is a Scovill whole-plate camera, fitted with the Eastman roll-holder; but he also carries a 4 x 5 camera, from which he enlarges and makes lantern-

slides. His pictures, illustrating geological phenomena, attracted much attention at an important exhibition held in Birmingham in connection with the visit of the British Association in September, 1886. From the Councils of the South Kensington Exhibitions of 1876 (Scientific Apparatus), and 1884 (Education), Mr. Harrison received in the one case the thanks of the Council, and in the other a Diploma of Honor for assistance rendered.

Mr. Harrison is Vice-President of the Birmingham Photographic Society, of which he was one of the founders, and is also a member of the Council of the Photographic Convention of Great Britain.

SPECIMEN OF ENGRAVING BY THE "MOSS-TYPE" PROCESS.

FROM A PHOTOGRAPH.

THE "MOSS-TYPE" is a method which has been introduced within the last few years. It is entirely original and different from other methods producing apparently similar results, and is a large step in the advance in the realm of photography as applied to illustrations as produced by printer's ink. Besides the superior excellence of the results shown and the ease with which they can be used on the ordinary printing press by any printer who understands cut printing, their cheapness, as compared with the other methods of illustration, makes this method of great importance to the publisher of periodicals, books and catalogues. For these reasons it is being very generally adopted by publishers of the present day as a substitute for the older methods of illustration. The copy for this method should be clean, sharp, distinct photographs with the outlines well defined. Also, from suitably prepared brush or pencil drawings, the most acceptable results are obtained, while very pleasing effects are secured from even the most ordinary photographs by having them touched up by our artists specially trained to this style of work.

Send green stamp for our circular "MOSS-TYPE SPECIMENS." *Send Photograph, Drawing or Print, for estimate.*

MOSS ENGRAVING CO.,
535 PEARL ST., NEW YORK.

iii

ALBUMEN PAPER.

───◄•●•►───

viii

The

RAMER

~·❀ PLATES. ❀·~

———·•·•·———

FOR SALE BY ALL DEALERS.

xi

Three Grades of Rapidity.

UNIFORM IN QUALITY.

ALWAYS RELIABLE.

Acknowledged to be unapproached for exquisite gradation of tone, giving perfect detail of printing quality, from the highest lights to the deepest shadows, thus producing **correct** reproductions of the objects photographed. When handled as directed, they do not require forcing in development or intensifying afterwards.

Portrait and Instantaneous.	Rapid Landscape.	Landscape and Transparency.
The most rapid plate in the market—indispensable for the Detective Camera.	Of most exquisite quality and fair speed, it is preëminently THE plate for out-door work and photo-micrography.	The plate chosen by the International Photographic Exchange as the best for Lantern Slides. A slow plate of unique qualities.

SPECIAL PLATES FOR LINE WORK.

Stripping Plates of Either Brand.

THE GEORGE H. RIPLEY CO., OF NEW YORK,
Office and Works: 32 Tiffany Place, Brooklyn, N. Y.

For sale by

SCOVILL MANUFACTURING CO.,

423 Broome Street, New York.

ESTABLISHED 1857.

CHAS. COOPER & CO.,

MANUFACTURING

CHEMISTS AND IMPORTERS,

194 WORTH STREET,

Near Chatham Square, NEW YORK.

Chemicals, Medicinal, Photographic,

AND FOR THE TRADES.

CHARLES COOPER, } New York.
JACOB KLEINHANS,
JOHN B. STOBAEUS, Newark.

Works at Newark, N. J.

Ready-Prepared Solutions

FOR PHOTOGRAPHERS' USES.

French Azotate (For Toning Prints).
Price, per bottle, **25 cts.**

S. P. C. Pyro and Potash Developer.
Price, per package, **60 cts.**

S. P. C. Carbonate of Soda Developer.
Price, per package, **50 cts.**

Hall's Intensifier (For Strengthening
Weak Negatives). Price, per bottle, . . . **75 cts.**

Flandreau's S. P. C. Hypo Eliminator
(For Removing every trace of Hyposulphite of
Soda from Negatives and Prints). Price, per bot-
tle, with book of testing paper, **50 cts.**

Flandreau's S. P. C. Orthochromatic
Solution, by which any plate may be rendered
color-sensitive. Price, per package, . . . **$1.50**

Flandreau's S. P. C. Retouching Fluid,
for Varnished or Unvarnished Negatives. Price,
per bottle, **25 cts.**

For sale by all dealers in Photographic Requisites, and by the

SCOVILL MANUFACTURING COMPANY.

xix

"PHOTOGRAPHIC PRINTING METHODS,"

A PRACTICAL GUIDE TO THE PROFESSIONAL AND AMATEUR WORKER.

Scovill's Photographic Series, Number Twenty-two.

By the Rev. W. H. Burbank,

Is a volume of more than 200 pages, uniform in size and type with the other numbers of the Scovill Photo· Series ; is neatly bound in cloth, with gilt titling ; and both inside and out makes a most attractive appearance.

Treating as it does of a field in photographic literature so long neglected, and one which is so important to all practical photographers, this book will undoubtedly have a wide sale; It is the only book in photographic literature to-day, which covers this ground, and it does so completely.

The chapters which it contains on the following subjects, give an idea of its completeness and practical value :

INTRODUCTION—THEORY OF LIGHT ; ACTION OF LIGHT UPON SENSITIVE COMPOUNDS RESUME OF PRINTING PROCESSES.
CHAPTER I.—PRINTING WITH IRON AND URANIUM COMPOUNDS.
CHAPTER II.—THE SILVER BATH.
CHAPTER III.—FUMING AND PRINTING.
CHAPTER IV.—TONING AND FIXING—WASHING.
CHAPTER V.—PRINTING ON OTHER THAN ALBUMEN PAPER.
CHAPTER VI.—THE PLATINOTYPE.
CHAPTER VII.—PRINTING WITH EMULSIONS.
CHAPTER VIII.—MOUNTING THE PRINTS.
CHAPTER IX.—CARBON PRINTING.
CHAPTER X.—PRINTING ON FABRICS
CHAPTER XI.—ENLARGEMENTS.
CHAPTER XII.—TRANSPARENCIES AND LANTERN SLIDES.
CHAPTER XIII.—OPAL AND PORCELAIN PRINTING.
CHAPTER XIV.—PHOTO. CERAMICS—ENAMELLED INTAGLIOS.
CHAPTER XV.—PHOTO-MECHANICAL PRINTING METHODS.
CHAPTER XVI.—VARIOUS METHODS FOR PUTTING PICTURES ON BLOCKS AND METAL PLATES FOR THE USE OF THE ENGRAVER.
CHAPTER XVII.—RECOVERY OF SILVER FROM PHOTOGRAPHIC WASTES—PREPARATION OF SILVER NITRATE, ETC.
INDEX.

It also contains two (2) full page illustrations, which alone are worth the price asked for the complete book.

PRICE, IN SUBSTANTIAL CLOTH BINDING, $1.00.

For sale by all dealers and by

SCOVILL MANUFACTURING CO., Publishers.

W. IRVING ADAMS, Agent.

SOME OPINIONS.

" A handsome, large octavo volume, * * * filled with formulæ and methods."— *Anthony's Photographic Bulletin.*

" It fills a field in Photographic literature which has long been neglected, and it does so completely."—THE PHOTOGRAPHIC TIMES.

" The photographic world will be under no small obligation for this very convenient compendium of all that is most wanted as information and instruction, whether to the practiced printer who sometimes forgets formulæ, or to the beginner who has them all to learn."—*The Nation.*

" A good general hand-book of printing methods has for some time been one of the things needed in the English language, and we congratulate the Rev. W. H. Burbank on the way he has filled the need."—*The Photographic News.*

" The reverend author is entitled to much credit."—*British Journal of Photography.*

" It is a splendid work—thoroughly practical. Well worth double its price."—*The Philadelphia Photographer.*

" The Rev. W. H. Burbank is to be congratulated upon his exploit."—*W. M. Ashman.*

" It is a valuable book for every photographic printer. It treats very thoroughly of all known processes."—*St. Louis Photographer.*

" This is the best selling book I ever had."—*Sam C. Partridge.*

More than 500 copies sold within the first month after publication.

A STANDARD BOOK OF REFERENCE.

THE

AMERICAN ANNUAL OF PHOTOGRAPHY

AND

"PHOTOGRAPHIC TIMES" ALMANAC

For 1887,

C. W. CANFIELD, Editor,

ARE RAPIDLY DISAPPEARING.

It contains five full page illustrations :

AN EXQUISITE PHOTO-GRAVURE, by Ernest Edwards.

A BROMIDE PRINT, by the Eastman Company.

A SILVER PRINT, by Gustav Cramer, of St. Louis.

TWO MOSSTYPES, by the Moss Engraving Company.

197 pages of **Contributed Matter,** consisting of articles on various subjects, by 80 representative writers of this country and Europe.

Also, in addition to the contributed articles :—Yearly Calendar. Eclipses, the Seasons. Church Days, Holidays, etc. Monthly Calendar, giving Sunrise and Sunset for every day in the year ; Moon's phases ; also, dates of meetings of all American Photographic Societies. A list of American and European Photographic Societies. Photographic Periodicals, American and European. Books relating to Photography, published 1886. Approved Standard Formulæ for all processes now in general use. Tables of Weights and Measures. American and Foreign Money Values. Comparisons of Thermometric Readings. Comparisons of Barometric Readings. Symbols and Atomicity of the Chemical Elements. Symbols, Chemical and common names and solubilities of the substances used in Photography. Tables for Enlargements and Reductions. Equations relating to Foci. Tables of Comparative Exposures. Freezing Mixtures. Photographic Patents issued 1886. Postage Rates. All Tables, Formulæ, etc., brought down to date and especially prepared or revised for this work

Price, per Copy, 50 Cents. Postage, 10c.
" *Cloth Bound, $1.00.* " "

A few author's copies, bound in white leatherette, gilt lettering, and printed upon laid paper, each $2.50.

For sale by all dealers, and by the publishers,

SCOVILL MANUFACTURING COMPANY,

Scovill's Photographic Series.

Price,
Per Copy.

No. 1.—THE PHOTOGRAPHIC AMATEUR.— By J. Traill Taylor. A Guide
to the Young Photographer, either Professional or Amateur. (Second Ed.) $0 50

No. 2.—THE ART AND PRACTICE OF SILVER PRINTING. (Second Edition) 5c

No. 3.—Out of print.

No. 4.—HOW TO MAKE PICTURES.—(Fourth edition.) The A B C of Dry-Plate
Photography. By Henry Clay Price. Illuminated Cover, 50 cts.;
Cloth Cover... 75

No. 5.—PHOTOGRAPHY WITH EMULSIONS.—By Capt. W. De W. Abney,
R.E., F.R.S. A treatise on the theory and practical working of Gelatine
and Collodion Emulsion Processes. (Second Edition.)..................... 1 00

No. 6.—No. 17 has taken the place of this book.

No. 7.—THE MODERN PRACTICE OF RETOUCHING.—As practiced by M.
Piguepé, and other celebrated experts. (Third Edition).................. 25

No. 8.—THE SPANISH EDITION OF HOW TO MAKE PICTURES.—Ligeras
Lecciones sobre Fotografia Dedicados a Los Aficionados................... 1 00

No. 9.—TWELVE ELEMENTARY LESSONS IN PHOTOGRAPHIC CHEM-
ISTRY.— Presented in very concise and attractive shape. (Second Edition.) 25

No. 10.—THE BRITISH JOURNAL PHOTOGRAPHIC ALMANAC FOR 1883. 25

No. 11.—Out of print.

No. 12.—HARDWICH'S CHEMISTRY.—A manual of photographic chemistry,
theoretical and practical. Ninth Edition. Edited by J. Traill Taylor,
Leatherette Binding... 2 50

No. 13.—TWELVE ELEMENTARY LESSONS ON SILVER PRINTING.
(Second Edition).. 50

No. 14.—ABOUT PHOTOGRAPHY AND PHOTOGRAPHERS.—A series of in-
teresting essays for the studio and study, to which is added European
Rambles with a Camera. By H. Baden Pritchard, F.C.S 50

No. 15.—THE CHEMICAL EFFECT OF THE SPECTRUM.— By Dr. J. M.
Eder .. 25

No. 16.—PICTURE MAKING BY PHOTOGRAPHY.— By H. P. Robinson.
Author of Pictorial Effect in Photography. Written in popular form and
finely illustrated. Illuminated Cover, 75 cts. ; Cloth................... 1 00

No. 17.—FIRST LESSONS IN AMATEUR PHOTOGRAPHY.— By Prof. Ran-
dall Spaulding. A series of popular lectures, giving elementary instruc-
tion in dry-plate photography, optics, etc. (Second Edition)............... 25

No. 18.—THE STUDIO: AND WHAT TO DO IN IT.— By H. P. Robinson.
Author of Pictorial Effect in Photography, Picture Making by Photog-
raphy, etc.; Illuminated Cover... 75

No. 19.—THE MAGIC LANTERN MANUAL.— (Second edition.) By W. I.
Chadwick. With one hundred and five practical illustrations ; cloth...... 75

No. 20.—DRY PLATE MAKING FOR AMATEURS.—By Geo. L. Sinclair, M.D., 50

No. 21.—THE AMERICAN ANNUAL OF PHOTOGRAPHY AND PHOTO-
GRAPHIC TIMES ALMANAC FOR 1887.—(Second Edition.) 50 cents;
(postage, ten cents additional). Cloth bound................. 1 00

No. 22.—PHOTOGRAPHIC PRINTING METHODS.—By the Rev. W. H. Bur-
bank. A Practical Guide to the Professional and Amateur Worker. Cloth
Binding.. 1 00

No. 23.— A HISTORY OF PHOTOGRAPHY : Written as a Practical Guide and an
Introduction to its Latest Developments, by W. Jerome Harrison, F. G. S.,
and containing a frontispiece of the author. Cloth bound................ 1 00

SCOVILL'S

OTHER

Photographic Publications.

Price,
Per Copy

HOW TO MAKE PHOTOGRAPHS.—Containing full instructions for making Paper Negatives. Sent free to any practitioner of the art. New edition just out..

ART RECREATIONS.—A guide to decorative art. Ladies' popular guide in home decorative work. Edited by MARION KEMBLE.................................... 2 00

THE FERROTYPERS' GUIDE.—Cheap and complete. For the ferrotyper, this is the only standard work. Seventh thousand.................................... 75

THE PHOTOGRAPHIC STUDIOS OF EUROPE.—By H. BADEN PRITCHARD, F.C.S. Paper, 50 cts.; Cloth...................................... 1 00

PHOTOGRAPHIC MANIPULATION.—Second edition. Treating of the practice of the art and its various applications to nature. By LAKE PRICE................. 1 50

HISTORY AND HAND-BOOK OF PHOTOGRAPHY.—Translated from the French of Gaston Tissandier, with seventy illustrations.......................... 2 50

AMERICAN CARBON MANUAL.—For those who want to try the carbon printing process, this work gives the most detailed information........................ 2 00

MANUAL DE FOTOGRAFIA.—By AUGUSTUS LE PLONGEON. (Hand-Book for Spanish Photographers.) Reduced to...................................... 1.00

SECRETS OF THE DARK CHAMBER.— By D. D. T. DAVIE.................$1 00

HOW TO SIT FOR YOUR PICTURE.—By CHIP. Racy and sketchy........... 30

THE PHOTOGRAPHER'S GUIDE.—By JOHN TOWLER, M.D. A text-book for the Operator and Amateur... 1 50

A COMPLETE TREATISE ON SOLAR CRAYON PORTRAITS AND TRANSPARENT LIQUID WATER COLORS.—By J. A. BARHYDT. Practical ideas and directions given. Amateurs will learn ideas of color from this book that will be of value to them. And any one by carefully following the directions on Crayon, will be able to make a good Crayon Portrait..................... 50

THE BRITISH JOURNAL ALMANAC FOR 1887.......... 50

PHOTO NEWS YEAR BOOK OF PHOTOGRAPHY for 1887................. . 50

CANOE AND CAMERA.—A Photographic tour of two hundred miles through Maine forests. By THOMAS SEDGWICK STEELE. Illustrated..................... 1 50

PADDLE AND PORTAGE.—By THOMAS SEDGWICK STEELE 1 50

PRACTICAL INSTRUCTOR OF PHOTO-ENGRAVING AND ZINC ETCHING PROCESSES.—By ALEX. F. LESLIE.............................. 50

PHOTO-ENGRAVING on Zinc and Copper in Line and Half-Tone, and PHOTO-LITHOGRAPHY. A Practical Manual, by W. T. WILKINSON. Cloth bound. .. 2 00

PHOTOGRAPHIC REFERENCE BOOKS.

Price,
Per Copy.

AMERICAN HAND-BOOK OF THE DAGUERREOTYPE.—By S. D. HUMPHREY. (Fifth Edition.) This book contains the various processes employed in taking Heliographic impressions........ 10

THE NEW PRACTICAL PHOTOGRAPHIC ALMANAC.— Edited by J. H. FITZGIBBON ... 25

MOSAICS FOR 1870, 1871, 1872, 1873, 1875, 1878, 1882, 1883, 1884.................... 25

BRITISH JOURNAL ALMANAC FOR 1878, 1882.............................. 25

PHOTO. NEWS YEAR-BOOK OF PHOTOGRAPHY FOR 1871, 1882.. 25

THE PHOTOGRAPHER'S FRIEND ALMANAC FOR 1873..... 25

Wilson's Photographic Publications.

Price,
Per Copy.

WILSON'S PHOTOGRAPHICS.— By EDWARD L. WILSON, Ph.D. The newest and most complete photographic lesson-book. Covers every department. 352 pages. Finely illustrated...................................... 4 00

WILSON'S QUARTER CENTURY IN PHOTOGAPHY. —By EDWARD L. WILSON, Ph.D. " The best of everything boiled out from all sources." Profusely illustrated, substantially bound... 4 00

THE PROGRESS OF PHOTOGRAPHY SINCE THE YEAR 1879.—By DR. H. W. VOGEL, Professor and Teacher of Photography and Spectrum Analysis at the Imperial Technical High School in Berlin. Translated from the German by Ellerslie Wallace, Jr., M. D. Revised by Edward L. Wilson, Editor of the *Philadelphia Photographer.* A review of the more important discoveries in Photography and Photographic Chemistry within the last four years, with special consideration of Emulsion Photography and an additional chapter on Photography for Amateurs. Intended also as a supplement to the Third Edition of the Handbook of Photography. Embellished with a full-page electric-light portrait by Kurtz, and seventy-two wood cuts.................................... 3 00

PHOTOGRAPHERS' POCKET REFERENCE BOOK.— By Dr. H. W. VOGEL. For the dark room. It meets a want filled by no other book. Full of formulas— short, practical and plain.......... 1 50

PICTORIAL EFFECT IN PHOTOGRAPHY.—By H. P. ROBINSON. For the art photographer. Cloth, $1.50 ; paper cover... 1 00

WILSON'S LANTERN JOURNEYS.—By EDWARD L. WILSON, Ph.D. In two volumes. For the Lantern Exhibitor. Gives incidents and facts in entertaining style of about 2,000 places and things, including 200 of the Centennial Exhibition. Per volume.. 2 00

THE PHOTOGRAPHIC COLORISTS' GUIDE.—By JOHN L. GIHON. The newest and best work on painting photographs ; Cloth........................ 1 50

PHOTOGRAPHIC MOSAICS. Published annually. Cloth bound, $1.00 ; Paper cover ... 50

PHILADELPHIA PHOTOGRAPHER.—PUBLISHED SEMI-MONTHLY. Illustrated. Per year, $5.00 ; with weekly PHOTOGRAPHIC TIMES............. 6 50

SOME OPINIONS

OF THE

PHOTOGRAPHIC TIMES.

I CONGRATULATE you on making the PHOTOGRAPHIC TIMES the leader of American photographic periodicals. A. B. STEBBINS.

WE cannot keep house without the TIMES. W. H. DUNWICK.

YOUR PHOTOGRAPHIC TIMES gets better every number. FRED. WHITEHEAD, Augustine, Fla.

I AM very much pleased with the TIMES, and value it more highly than any other I have seen. JOHN M. RAE, Sutton, West, P. O.

AFTER seeing a specimen copy I could not possibly do without the PHOTOGRAPHIC TIMES, FRED. WHITEHEAD, Augustine, Fla.

WITHOUT your journal the fraternity are behind the times, and, like a crab, are moving backwards. A. K. A. & M. LIEBICH, Cleveland, O.

ANY Photographer that will go without the TIMES weekly, ought to go without his head. J. W. ALLDINGS, Waterbury.

IT is a most admirably arranged journal, presents a handsome appearance, and is a credit to its publishers. JOHN WORTHINGTON, *U. S. Consul.*

IN behalf of the TIMES allow me to say that I have been a regular subscriber for nearly three years, and though I take a large number of journals of various kinds, there is none I look for with more interest than the TIMES. PROF. W. S. GOODNOUGH.

I BELIEVE it unnecessary to state that I regard the TIMES as one of the best journals devoted to photography published in the English language, and find many others of a like opinion. JOHN G. CASSELBAUN.

ALL here (England) who have any real knowledge of the subject, agree that the TIMES is the best medium in America W. M. ASHMAN.

I BIND my TIMES each year, and find it makes, with a good index, a very valuable storehouse of information. G. F. H. BARTLETT.

I RECEIVE my weekly TIMES, and am delighted with its fresh and instructive contents, giving at all times something to think about and experiment with. A. S. MURRAY, *President of the Pittsburgh Amateur Photographic Society.*

As times were rather tight this spring, I thought to economize by taking the ———, but it is too much watered—too thin entirely, too much chaff to the kernel of wheat. I can't live on husks alone ; please take pity on me and send the weekly PHOTOGRAPHIC TIMES from the beginning of the present volume, and oblige, E. FERRIS, Malone, New York.

THE TIMES is a very great help to beginners in the art of photography like myself. Unlike many other journals, your articles are practical and simple, and a wonderful help to those of us who are trying to learn to "take pictures." I read it with intense interest, and hope that you will continue to make it a journal for amateurs as well as for those more advanced in the art. A. D. CUTTER, Cleveland, O.

THE LITERATURE OF PHOTOGRAPHY
AN ARNO PRESS COLLECTION

Anderson, A. J. **The Artistic Side of Photography in Theory and Practice.** London, 1910

Anderson, Paul L. **The Fine Art of Photography.** Philadelphia and London, 1919

Beck, Otto Walter. **Art Principles in Portrait Photography.** New York, 1907

Bingham, Robert J. **Photogenic Manipulation.** Part I, 9th edition; Part II, 5th edition. London, 1852

Bisbee, A. **The History and Practice of Daguerreotype.** Dayton, Ohio, 1853

Boord, W. Arthur, editor. **Sun Artists** (Original Series). Nos. I-VIII. London, 1891

Burbank, W. H. **Photographic Printing Methods.** 3rd edition. New York, 1891

Burgess, N. G. **The Photograph Manual.** 8th edition. New York, 1863

Coates, James. **Photographing the Invisible.** Chicago and London, 1911

The Collodion Process and the Ferrotype: Three Accounts, 1854-1872. New York, 1973

Croucher, J. H. and Gustave Le Gray. **Plain Directions for Obtaining Photographic Pictures.** Parts I, II, & III. Philadelphia, 1853

The Daguerreotype Process: Three Treatises, 1840-1849. New York, 1973

Delamotte, Philip H. **The Practice of Photography.** 2nd edition. London, 1855

Draper, John William. **Scientific Memoirs.** London, 1878

Emerson, Peter Henry. **Naturalistic Photography for Students of the Art.** 1st edition. London, 1889

*Emerson, Peter Henry. **Naturalistic Photography for Students of the Art.** 3rd edition. *Including* The Death of Naturalistic Photography, London, 1891. New York, 1899

Fenton, Roger. **Roger Fenton, Photographer of the Crimean War.** With an Essay on his Life and Work by Helmut and Alison Gernsheim. London, 1954

Fouque, Victor. **The Truth Concerning the Invention of Photography:** Nicéphore Niépce—His Life, Letters and Works. Translated by Edward Epstean from the original French edition, Paris, 1867. New York, 1935

Fraprie, Frank R. and Walter E. Woodbury. **Photographic Amusements Including Tricks and Unusual or Novel Effects Obtainable with the Camera.** 10th edition. Boston, 1931

Gillies, John Wallace. **Principles of Pictorial Photography.** New York, 1923

Gower, H. D., L. Stanley Jast, & W. W. Topley. **The Camera As Historian.** London, 1916

Guest, Antony. **Art and the Camera.** London, 1907

Harrison, W. Jerome. **A History of Photography Written As a Practical Guide and an Introduction to Its Latest Developments.** New York, 1887

Hartmann, Sadakichi (Sidney Allan). **Composition in Portraiture.** New York, 1909

Hartmann, Sadakichi (Sidney Allan). **Landscape and Figure Composition.** New York, 1910

Hepworth, T. C. **Evening Work for Amateur Photographers.** London, 1890

*Hicks, Wilson. **Words and Pictures.** New York, 1952

Hill, Levi L. and W. McCartey, Jr. **A Treatise on Daguerreotype.** Parts I, II, III, & IV. Lexington, N.Y., 1850

Humphrey, S. D. **American Hand Book of the Daguerreotype.** 5th edition. New York, 1858

Hunt, Robert. **A Manual of Photography.** 3rd edition. London, 1853

Hunt, Robert. **Researches on Light.** London, 1844

Jones, Bernard E., editor. **Cassell's Cyclopaedia of Photography.** London, 1911

Lerebours, N. P. **A Treatise on Photography.** London, 1843

Litchfield, R. B. **Tom Wedgwood, The First Photographer.** London, 1903

Maclean, Hector. **Photography for Artists.** London, 1896

Martin, Paul. **Victorian Snapshots.** London, 1939

Mortensen, William. **Monsters and Madonnas.** San Francisco, 1936

*****Nonsilver Printing Processes:** Four Selections, 1886-1927. New York, 1973

Ourdan, J. P. **The Art of Retouching by Burrows & Colton.** Revised by the author. 1st American edition. New York, 1880

Potonniée, Georges. **The History of the Discovery of Photography.** New York, 1936

Price, [William] Lake. **A Manual of Photographic Manipulation.** 2nd edition. London, 1868

Pritchard, H. Baden. **About Photography and Photographers.** New York, 1883

Pritchard, H. Baden. **The Photographic Studios of Europe.** London, 1882

Robinson, H[enry] P[each] and Capt. [W. de W.] Abney. **The Art and Practice of Silver Printing.** The American edition. New York, 1881

Robinson, H[enry] P[each]. **The Elements of a Pictorial Photograph.** Bradford, 1898

Robinson, H[enry] P[each]. **Letters on Landscape Photography.** New York, 1888

Robinson, H[enry] P[each]. **Picture-Making by Photography.** 5th edition. London, 1897

Robinson, H[enry] P[each]. **The Studio, and What to Do in It.** London, 1891

Rodgers, H. J. **Twenty-three Years under a Sky-light,** or Life and Experiences of a Photographer. Hartford, Conn., 1872

Roh, Franz and Jan Tschichold, editors. **Foto-auge, Oeil et Photo, Photo-eye.** 76 Photos of the Period. Stuttgart, Ger., 1929

Ryder, James F. **Voigtländer and I:** In Pursuit of Shadow Catching. Cleveland, 1902

Society for Promoting Christian Knowledge. **The Wonders of Light and Shadow.** London, 1851

Sparling, W. **Theory and Practice of the Photographic Art.** London, 1856

Tissandier, Gaston. **A History and Handbook of Photography.** Edited by J. Thomson. 2nd edition. London, 1878

University of Pennsylvania. **Animal Locomotion. The Muybridge Work at the University of Pennsylvania.** Philadelphia, 1888

Vitray, Laura, John Mills, Jr., and Roscoe Ellard. **Pictorial Journalism.** New York and London, 1939

Vogel, Hermann. **The Chemistry of Light and Photography.** New York, 1875

Wall, A. H. **Artistic Landscape Photography.** London, [1896]

Wall, Alfred H. **A Manual of Artistic Colouring, As Applied to Photographs.** London, 1861

Werge, John. **The Evolution of Photography.** London, 1890

Wilson, Edward L. **The American Carbon Manual.** New York, 1868

Wilson, Edward L. **Wilson's Photographics.** New York, 1881

All of the books in the collection are clothbound. An asterisk indicates that the book is also available paperbound.